MURDER AND MAYHEM
IN THE
NAPA VALLEY

TODD L. SHULMAN

THE
History
PRESS

Published by The History Press
Charleston, SC 29403
www.historypress.net

First published 2012
Second printing 2013
Third printing 2014

Manufactured in the United States

ISBN 978.1.60949.544.2

Library of Congress Cataloging-in-Publication Data

Shulman, Todd L.
Murder and mayhem in the Napa Valley / Todd L. Shulman
p. cm.
Includes bibliographical references.
ISBN 978-1-60949-544-2
1. Murder--California--Napa Valley--History. 2. Violent crimes--California--Napa Valley--
History. 3. Napa Valley (Calif.)--History. 4. Napa Valley (Calif.)--Biography. 5. Napa Valley
(Calif.)--Social conditions. I. Title.
HV6533.C2S49 2012
363.152'30979419--dc23
2012029026

A gift for you

Merry Christmas !!! From Mike Donnoe

amazon Gift Receipt

Send a Thank You Note

You can learn more about your gift or start a return here too.

Scan using the Amazon app or visit
https://a.co/d/3wlSEa6

Murder and Mayhem in the Napa Valley (Murder & Mayhem)
Order ID: 111-7420427-6264253 Ordered on December 10, 2022

CONTENTS

CONTENTS

FOREWORD

The picturesque, bucolic Napa Valley would seem an unlikely setting for Wild West violence and hard-boiled true crime drama. Visitors to Napa County expect wine tasting and tours of vineyards, not stories of gunfights, outlaws and lawmen, murder triangles, serial sex killers and prostitutes. So Napa County's civic boosters and its chambers of commerce might not be too happy with the latest contribution to local history from Napa police detective Todd Shulman. For here is a remarkable series of tales from the seamier side of the wine country's history.

Academic historians generally concentrate on political, cultural, social, economic and military history. Professional historians often view crime as either unimportant, too difficult to make sense of or otherwise too messy and grubby for serious study. Fortunately, that academic bias is changing, for the history of the American West in general, and California in particular, cannot be understood without recognizing the enormous rates of violent crime during the frontier era. During the gold rush period of the 1850s, California saw statewide homicide rates seventeen times higher than the modern national rate. The reasons ranged from the development of the Colt repeating revolver to excessive drinking by a largely young and male population, conflict over women and gold and racial strife, especially between Anglos and Hispanics. All of these factors will be found in the many stories of Napa violence in the pages that follow.

Todd Shulman begins his book with the heartbreaking story of Napa County's first murder trial, in 1850. Its villains were the notorious Kelsey

brothers, founders of the town of Kelseyville, and its massacred victims the enslaved members of the local tribe of Pomo Indians. From here he takes us on a tour of murder and mayhem. He describes the early lynchings in Napa County and the conditions that led pioneers to take the law into their own hands. The story of James Gilbert Jenkins, a notorious cutthroat, is detailed, along with his legal execution by the sheriff on the gallows in Napa just two months after his murderous crime. The timing is noteworthy when one considers today the number of killers who have spent twenty years or more on San Quentin's death row.

Napa's most famous murder case of the nineteenth century did not involve a notorious outlaw. The killer was Eadweard Muybridge, the brilliant pioneer photographer and inventor of motion pictures. Among the many stories from that era is that of Buck English, Napa's most noted highwayman and desperado. But Shulman does not limit himself to the Old West. Instead, he draws us in with accounts of twentieth-century murder mysteries and cold cases, at least one of which he has examined himself as a cold case investigator. And the most notorious Napa killer of them all, the Zodiac, even makes his appearance in these pages.

In his latest book, Todd Shulman has made a significant contribution to California history. Those who live in or visit the Napa Valley might never look at it in the same way again.

John Boessenecker is the award-winning author of numerous books on crime and law enforcement in frontier California

ACKNOWLEDGEMENTS

Trying to write a book about events that happened over 150 years ago can be a daunting task, to say the least. I pride myself on being as accurate as possible in my writing; however, in the case of most of the stories contained herein, there are no first-person witnesses to interview; they've all long since passed away. My background in law enforcement has taught me in real life the lessons many of us learned playing the game of "telephone" as children: details passed from person to person to person almost always are distorted, embellished or just plain wrong. This phenomenon isn't due to malicious intent, it's just human nature; most people aren't trained observers.

Without eyewitnesses to interview, I've resorted to the next best thing: accounts of the events that were written at the time or shortly after the events occurred. An invaluable resource has been the California Digital Newspaper Collection (CDNC), an online repository of many historic newspapers. I've also spent countless hours sitting in front of the microfiche machine at the Napa City–County Library, poring over Napa newspapers and visiting the secretary of state's archives in Sacramento. Trips to historical societies in both Napa and Sonoma Counties were also important research stops.

Several fellow history writers and researchers have been invaluable resources in finding details on stories contained herein. In particular, Mariam Hansen of the St. Helena Historical Society and Tobi Shields were instrumental in bringing forward several notable crimes that I had no knowledge about. Retired Napa County Superior Court judge Philip Champlin provided much-needed details on early Napa trials and crimes. I

am also grateful for the detailed Napa County history books authored by Lin Weber, whose careful sourcing for information proved very helpful.

Lastly, I would like to thank John Boessenecker for reading my book and providing the foreword. John is an award-winning western historian and author and served as an inspiration when I first became interested in early California law enforcement history several years ago.

INTRODUCTION

The Napa Valley today is synonymous with fine wine, known worldwide for the varietals of the dozens of wineries that dot the valley floor and hillsides. Thousands of tourists travel from around the world to enjoy a variety of getaway destination activities such as wine tastings, spa outings and hot-air balloon excursions. It wasn't always that way.

The Napa Valley first came to the attention of European settlers in the 1830s with the exploration of the Spanish from the nearby mission at Sonoma. After Mexico gained its independence from Spain, the government granted wide swaths of California to prominent citizens. The Mexican land grantees were soon followed by pioneering American settlers. These pioneer settlers found a secluded valley teeming with wild game and thick with verdant forests and wild streams.

Prior to the Mexican-American War and statehood, "Alta California," as present-day California was known to the Mexican government, was divided into districts. The large district of Sonoma, which included all the territory between the Sacramento River and the Pacific Ocean and Oregon and the Bay of San Francisco, had its base in the town of Sonoma, which is about fifteen miles west of Napa, in present-day Sonoma County. Early justice came in the form of an *alcalde*, a position that has its roots in Spanish tradition and was used most extensively in Spain's overseas colonies, such as Mexico. The alcalde served as the district's mayor, chief law enforcement officer, judge, mediator, assessor, notary and tax collector.

The Napa Valley became Napa County when California statehood was achieved in 1850. With the county government came the first elected sheriff, justices of the peace, judges, town marshals and constables. These men (I say men because up until about forty years ago, law enforcement was a males-only affair) did their best to bring law and order to the valley. For the most part they succeeded, although wherever people congregate and settle crime will surely follow.

Despite the valley's insulated nature, it hasn't been immune to serious crimes and scandals. I hope to highlight with this book some of these infamous crimes, many of which gained notoriety throughout the Bay Area, the state and some throughout the country. Jealousy, envy, revenge, intolerance and debauchery are all featured in the stories within these pages. I learned through my research that there are many more stories to be told, just as compelling as the ones I've chosen, and I hope this book will pique your interest to learn more. I hope the stories in this book will memorialize the victims; the trauma the crimes caused their families; and the community and the efforts of Napa County law enforcement to bring those responsible to justice.

CHAPTER 1
THE FIRST MURDER TRIAL

The first documented murder trial in the Napa Valley occurred in 1850. It would also become the first criminal case heard before the California Supreme Court. It was in these uncharted, untested legal waters that the Napa Valley would find itself. The prosecution of a band of men for the massacre of Indians in the valley would lead to controversy and unresolved justice that had terrible implications. To understand why the massacre occurred, we first have to understand the lives of the murderers and the Indians and the growing pains going on in the fledgling state.

At the end of the Mexican-American War in early 1848, the U.S. military temporarily took over control of California to allow time for the formation of a constitutional convention, the writing of a state constitution and the nomination and election of state officials. General Bennett C. Riley was appointed the military governor. He commissioned Stephen Cooper as the judge for the district of Sonoma, an area similar to the prior area administered under Mexican rule by an alcalde. The district of Sonoma encompassed much of Northern California north of San Francisco and was governed from the town of Benicia.

One key family involved in the massacre was the Kelseys. Three siblings—Samuel, Andrew and Benjamin—were Missouri natives. In 1841, two of the brothers, Andrew and Benjamin, traveled via wagon train to California. Benjamin brought along his eighteen-year-old wife, Nancy, believed to be the first American woman to enter California via an overland route. Samuel followed several years later. Even before they left Missouri, the Kelsey

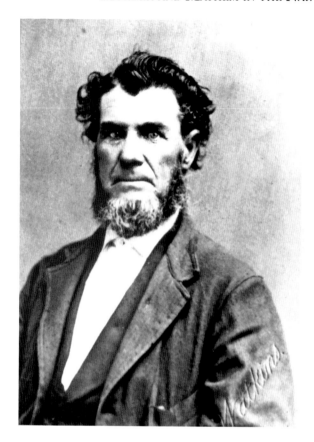

Benjamin Kelsey, one of the members of Captain Smith's "company" of men who attacked several Indian encampments in the Napa Valley. *Courtesy of the Humboldt County Historical Society.*

family had a bad reputation. They were accused by fellow settlers of filing preemptive claims on parcels of land, a land grab of sorts. In 1838, Samuel had been accused of attempted murder, although the indictment was later quashed. The extended Kelsey family settled in and around Sonoma, in the Napa Valley and in present-day Lake County.

During the Bear Flag Revolt of 1846, the brothers were active participants; even Nancy got involved. Several historical sources report that she was the "Betsy Ross of California" for fashioning the rebels' Bear Flag, which was later the model for the California state flag. It is perhaps more accurate that William L. Todd, a nephew of Mary Todd Lincoln, actually designed and created the first flag and Nancy created one of several copies that were taken to nearby cities to be flown as acts of defiance toward the Mexican government.

Benjamin Kelsey treated the Indians he encountered with the disdain that his family was notorious for. After the Bear Flag Revolt, Benjamin decided

to get in on the gold rush in the Sierra Nevada Mountains. He and some partners conscripted between fifty and one hundred Pomo Indians from the Lake County area and took them to the mountains as miners. When the gold didn't come tumbling from the rocks and Benjamin contracted malaria, he sold the group's supplies and hightailed it back to Sonoma, leaving the Indians to fend for themselves, camped in the hostile territory of a rival tribe. By some accounts, only three of the enslaved Pomos made it back to Lake County alive.

At the same time, Andrew Kelsey and Charles Stone set up a cattle ranch at the north end of Clear Lake in present-day Lake County on land they purchased from Mexican land grantee Salvador Vallejo. They conscripted the local Pomo Indians to work the ranch as little more than slaves. It was common practice at the time for indigenous Indians to work as vaqueros (cowboys) or as farmhands. It was, in fact, a necessity due to the low population of white settlers in early California. Contemporary reports uniformly describe the harsh treatment of the Indians by Kelsey and Stone, who scantly fed the Indians, took liberties with young Indian women and punished perceived transgressions with whippings or summary execution. The Indians were forced to build the adobe residence of Kelsey and Stone. Later, the site of this structure paved the way for the founding of the present-day town of Kelseyville. The Indians were also forced to build a fence around their nearby rancheria, creating their own de facto prison, meant to prevent the Indians from escaping or hunting for food at night. These deplorable conditions came to a head in December 1849, when the desperate Indians selected two of their number to sneak out of the rancheria, borrow horses from Kelsey and Stone's barn and use them to hunt for game to feed the masses. During the clandestine outing, one of the horses bolted, running off into the wilderness. This presented the Indians with a problem. They knew that retribution from Kelsey and Stone would be swift and harsh. Indeed, the duo treated their horses better than they did the Indian laborers. The Indians held a meeting and debated what to do. Some in the number wanted to lie and say the horse was stolen; others wanted to tell the truth and accept their punishment. In the end, the group decided that their only viable course of action was to eliminate their tormenters once and for all. A band of five men was chosen, and they went to the adobe early the next morning and shot Stone in the stomach with an arrow. Kelsey tried to run off, but he was stabbed and shot with an arrow.

The Kelsey family, already predisposed to dislike and mistreat Indians, were determined to take revenge not only on those personally responsible for the murders of Andrew Kelsey and Charles Stone but also on any Indians they encountered. They enlisted the aid of a group of like-minded men from the Sonoma area, most notably a man named Joseph Smith, who called himself "Captain Smith," although there is no record of him holding a military commission. Sonoma historian Barbara Warner provided Smith's nickname as "Growling Mad Smith." The company of men numbered about twenty-one when they left on horseback from the town of Sonoma in late February 1850, en route to the Napa Valley. Some contemporary reports indicate that the men split into two groups and attacked different areas within the valley. However, based on the court testimony, it appears there was only one company and that it headed up-valley from the south, attacking at least two separate Wappo Indian rancherias.

The first rancheria they came to was located next to the ranch of George C. Yount. Yount was the first white person to set up a permanent residence in the Napa Valley, receiving a land grant in 1836 from the Mexican landholder General Mariano Vallejo in exchange for doing carpentry work at Vallejo's settlement in the town of Sonoma. Yount recalled in vivid detail during the subsequent trial what transpired. He said that he was first contacted by John Kelly, Julius Graham and "Captain" Joseph Smith. They met Yount at the Indian rancheria next to his ranch and called the Indians out of their huts. As the rest of the company arrived, they then ordered Yount to separate out any of his Indian workers who had come from "the lake" (referring to Clear Lake). Yount then made an impassioned plea in defense of the Indians. He pointed out to the men that the Indians at his ranch were mostly women and children, most of them had been working for him for twelve to fifteen years, they had helped fight off marauding bands of Walla Walla Indians who had invaded Northern California from Oregon years earlier, none of them had been involved in the Kelsey and Stone killings and he had already sent a letter to the military commander at the Sonoma arsenal asking how he could protect the Indians at his ranch. Yount, never one to shy away from a challenge, demanded to know on what authority the men were acting. The men claimed to be operating under orders of "the captain" (Smith). Yount tried to negotiate with the men, asking them to wait until the commander from the arsenal in Sonoma arrived. Kelly told Yount that he and his men were going up to drive the "lake" Indians into the mountains. The company

of horsemen then set the Indians' huts ablaze. The only saving grace was that due to an unusual snowfall the night before, several huts were too wet to burn. The Indians at the rancheria near Yount's ranch were driven out into the mountains by the company, shivering in the cold since most of their clothing and belongings had burned up. In addition, a large portion of threshed wheat that was stored at the rancheria burned. Yount estimated the damages and losses of wheat at $5,000. The company of horsemen was last seen riding north, deeper into the Napa Valley.

On the night of February 27, 1850, the company arrived at the ranch of Henry Fowler and James Hargrave. Fowler and Hargrave had purchased the land, the site of the present-day city of Calistoga, from Dr. Edward Bale, the first white settler in the area. They set up a successful farm and cattle ranch, using laborers from the nearby Wappo Indian tribe. The relationship with the Indians was symbiotic for Fowler, Hargrave and the other ranchers in the valley: they received the manpower needed to keep their ranch running and, in turn, clothed and fed the Indians and their families.

The company of men, led by "Captain" Smith, forced Fowler to separate the Indians on the rancheria near his ranch, asking him to point out which Indians he could not do without. Another man, Elias Graham, then entered each of the rancheria's lodges and gathered up all the bows and arrows. Now confident that all the Indians were unarmed, Samuel Kelsey, still astride his horse, leveled a rifle and shot one of the "unneeded" Indians dead on the spot. The other Indians began to run away as the rest of the company of men chased them, raining bullets upon them. The next morning, Fowler and Hargrave returned to the rancheria and found about ten Indians lying dead within the rancheria; their bodies had been stacked and partially burned by fire. The ranchers surmised that the Indian women had gathered and burned the bodies after the company had ridden off. Three more Indians were found lying dead several hundred yards away from the rancheria, unable to outrun the armed company on horses.

The result of the Napa Valley atrocities, as reported in the *Daily Alta California* newspaper, was to drive hundreds of Indians into the mountains surrounding the valley, in near starvation, afraid to return to their rancherias and employment for the white settlers.

Seven men were arrested by the district of Sonoma sheriff: Joseph Smith, Samuel Kelsey, John Kelly, Julius Graham, Arthur Graham, Stewart Lewis and James Lewis. In addition to the seven arrested defendants, seven

more men were identified as being present, and seven men were charged as accessories since they were part of the company but disagreed with "Captain" Smith and Samuel Kelsey's orders to kill the Indians at the Fowler and Hargrave ranch. Among this group of accessories was Benjamin Kelsey. The fourteen men who were not initially arrested were all released on bail by Judge Stephen Cooper.

A preliminary hearing for the seven arrested men was held on March 7 in front of Judge Cooper in the town of Benicia. Since the state district court system had yet to be established, Judge Cooper's jurisdiction included a wide swath of Northern California, including the Napa Valley. The arrested men were held temporarily aboard the USS *Savannah*, the flagship of the U.S. Navy's Pacific Squadron and a veteran of the Mexican-American War. The ship was anchored in the Carquinez Straights, off the shore of Benicia. They would serve a total of seven days in custody.

The defendants appealed the findings of the preliminary hearing to the California State Supreme Court. They argued four legal points: first, that the

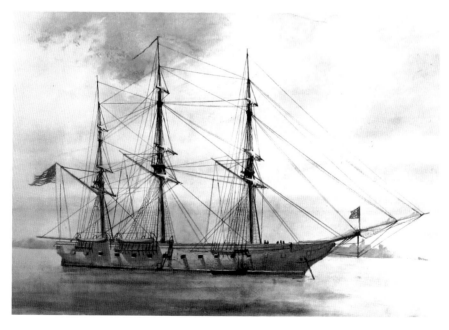

The USS *Savannah* was a frigate built in 1842. It served as the flagship for the U.S. Navy's Pacific Squadron and saw action along the California coast during the Mexican-American War. In 1850, the ship was moored off Benicia when it served as a temporary jail for the seven men arrested from Captain Smith's "company." *Courtesy of Historylink101.com.*

affidavit used to obtain the original arrest warrants was defective. Second, that the order by Judge Cooper to confine the defendants indefinitely was illegal. Third, that the alleged crimes didn't occur in the state of California since the state hadn't been formed yet. Finally, that Judge Cooper had overstepped his legal authority.

At the time, the state Supreme Court had just moved into one of the upper floors of a converted hotel in San Francisco, located at the corner of Kearny Street and Pacific Avenue. It shared the building with city hall, police headquarters and the city jail. The court reviewed the original trial transcripts and apparently felt strongly enough about the case to sign an order directing Luther Wright, the sheriff of the district of Sonoma, to transport the defendants to San Francisco and house them for the hearing. A bill is still retained in the state archives from Sheriff Wright noting that he spent $46.87 for blankets and mattresses, $210.00 in ferryboat fares and $132.00 to cover payment for the sheriff and six guards.

In the end, the state Supreme Court denied all the defendants' appeals; however, it did decide to release the defendants on $10,000 bail. Although not intending to do so, the justices in effect gave the defendants a "get out of jail free" card, since they would never set foot in a courtroom again. There is no record of why they were never tried once the state established the district court system. In fact, it doesn't appear anyone even attempted to track them down after they skipped bail.

A large portion of the "company" involved in the Napa Valley massacre decided it was time for a change of scenery. Not waiting around to see if the court system in Napa ever got up and running, they joined a group known as the Union Company, boarded a schooner in San Francisco and headed for Humboldt Bay, located on the coast of California northwest of the Napa Valley. They were lured by a recent gold rush in the area and decided to cash in by establishing a settlement nearby. The group formed the town of Union, which would later be incorporated as the present-day city of Arcata.

Perhaps a clue as to why the case was never followed up happened on May 15 of the same year, when the U.S. Cavalry would complete the task that Samuel Kelsey and his misguided "company" couldn't. A regiment of U.S. Army dragoons (cavalry) and infantry culled from military bases in the towns of Sonoma and Benicia traveled north through the Napa Valley to the northern shores of Clear Lake in present-day Lake County. Their orders were clear: to eliminate the band of Indians who had killed Andy Kelsey and

Charlie Stone. The army cornered a band of Pomo Indians consisting of men, women and children on a spit of land at the north end of the lake and, assisted by two whale boats with howitzers mounted on them, rained shells and shot down on the Indians. Estimates vary wildly as to how many Indians were killed, with ranges from sixty to one hundred. The incident became known as the Bloody Island Massacre. Not satisfied with this "victory," the military expedition then traveled to the Russian River area of Sonoma County and killed another seventy-five Indians.

Even after their brush with justice, or perhaps emboldened by getting away scot-free, the Kelseys and their compatriots continued to stir up trouble. While in Humboldt County, members of the Napa Valley "company," including Joseph Smith, participated in raids and murders of Indians on the slightest of pretenses. Some in the Union Company felt that the Kelsey faction brought unwanted and unneeded trouble, as evidenced by settler L.K. Wood, who later wrote, "Four of the recruits were arrested for murder. Six should have been arrested, and five of the six hanged, as they never quit Indian killing, but kept it up after reaching here, which was the first cause of our Indian troubles." Joseph Smith died in Humboldt County in 1855. Later, during the Civil War, Benjamin Kelsey would move to San Bernardino County, where he formed a band of Confederate sympathizers.

The confusion within the court system as evidenced by this, the first case the state Supreme Court heard, and the ambivalence toward the native population were only part of the growing pains experienced as California was born as a state.

CHAPTER 2
TOO LATE TO STAY

In 1850, the role of justice of the peace in California was spelled out during the first legislative session of the fledgling state. Justices of the peace were elected by and served within specific townships. They primarily heard civil cases dealing with $200 or less in loss (quite a big sum in 1850) and petty crimes such as larceny or assault. Despite the role as outlined by the legislature, records in Napa County indicate that justices of the peace also presided over preliminary hearings connected to felonies committed within their townships. The idea of this arrangement was to defuse the distrust that existed at that time between the townships and the county seat.

One such justice of the peace was Simon H. Sellers, an Ohio native who left behind a widowed mother and infirm sister to try his fortunes out west. In August 1849, Sellers arrived in what was then called Napa City. The town had only recently begun to be resettled after its initial establishment in 1848; a mass exodus had emptied the town on the heels of the discovery of gold in the California foothills. Shortly after arriving, Sellers was elected justice of the peace, a post that would lead to his untimely death within two years' time.

In 1851, Sellers presided over a civil case involving George C. Yount and Isaac Howell. Yount was a pioneer of the early Napa Valley who settled in the area north of the city of Napa, founding a settlement named Sebastopol; later, the settlement he established would be renamed Yountville in his honor. Howell was also an early Napa Valley settler; a local landmark, Howell Mountain, was named after him. On the trial date, March 2, 1851, Yount failed to show up, and Sellers dismissed the case. This enraged one

of Yount's relatives, Hamilton McCauley, a transplant from New Franklin, Missouri, where he had been a constable for a period of time. Friends would later describe McCauley as being peaceable and well disposed, although he was liable to excesses of passion while drunk.

McCauley decided to distract himself from his troubles by engaging in a card game at a mercantile in downtown Napa. A short time later, Justice Sellers walked into the store, and McCauley sprang upon the opportunity to berate Sellers for the perceived bias shown by dismissing the civil case. McCauley's tirade ended with a threat to beat Sellers to a pulp. Sellers replied that he wouldn't fight McCauley, but Sellers offered to send for his African American servant to be a stand-in fighter. One back story alleged that this was the worst thing to say to McCauley, since sometime prior McCauley had been on the losing end of a fight with a black man, and since McCauley hailed from the South, his honor had already been besmirched. In any case, the comment enraged McCauley even more than he had already been, and he pulled a bowie knife. He plunged the knife into Sellers's chest, and as Sellers collapsed, McCauley followed this with two quick stabs to Sellers's back.

McCauley was quickly detained by onlookers and turned over to the town constable. Unfortunately for McCauley, Napa County had yet to construct a jail. At the time, prisoners were either transported to the old adobe jail in the town of Sonoma or they were shackled and chained to the floor in a room on the second story of a commercial building downtown. Napa's first sheriff, Nathaniel McKimmey, decided to keep McCauley in the Napa building, a move that would seal McCauley's fate.

On the day of Sellers's funeral, businesses in town closed to honor his life, showing just how popular he was. The murder tore the small town apart, with those from southern states supporting McCauley and Yount and those from northern states supporting Sellers. McCauley's lawyers tried in vain to get a change of venue for their client, arguing that it would be impossible to get a fair trial in Napa. Despite their attempts, the trial was held in Napa. The jury in the case returned a guilty verdict on March 13, and McCauley was sentenced to be hanged on April 14.

Knowing that McCauley might not make it to his official execution date based on the fervor stirring among Napa residents to take justice into their own hands, McCauley's lawyers traveled to the city of Benicia, which was then the state capital. They lobbied the state legislature to pass a law providing the state Supreme Court power to commute death sentences. The lawyers

also filed an appeal with the state Supreme Court, arguing that the trial court judge erred when he denied a defense motion to delay the trial due to an unavailable witness and in the content of the instructions read to the jury before they began their deliberations. The chief justice of the state Supreme Court wrote a recommendation to then-governor John McDougal asking to stay the execution for one month to allow the state Supreme Court time to review the case; the governor agreed and, on April 10, penned a stay of execution.

At least one Napan who sided with Sellers was in the state capital and learned of the stay of execution. This person chartered the steamship *Dolphin* and sailed from Benicia up the Napa River to deliver the news to the unhappy citizens. This route was quicker than that of Solano County sheriff Paul Shirley, the courier dispatched by horseback from Benicia to deliver the stay of execution. Sheriff Shirley rode through the eastern entry into the Napa Valley via Jameson Canyon. At the time, there were no bridges crossing the Napa River and thus no direct route to the city of Napa. Travelers would routinely head to the Suscol ferry crossing, several miles south of the city, and cross the river via ferry. Sheriff Shirley arrived at the ferry to find it on the far side of the shore, and the ferry master either didn't see Sheriff Shirley or he was part of Sellers's faction. The only other way to reach the city of Napa was to ride several miles north of the city to a site known as "las trancas" (now called Trancas Street), where the river was shallow enough for a horse to ford it.

The mob that formed after hearing about the impending stay of execution used Sheriff Shirley's delay to their advantage. When the sheriff finally arrived in downtown Napa it was after 2:00 a.m. He was perplexed to find the front door to the building where McCauley was housed, located at the

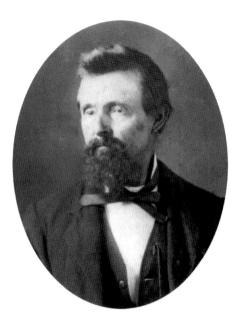

Nathaniel McKimmey was Napa County's first sheriff. In 1851, he was thrown headlong into a scandalous lynching of Hamilton McCauley. *Courtesy of California State Library.*

Las Trancas was a section of the Napa River just north of Napa shallow enough to allow the river to be forded. *Author's collection.*

intersection of Main and Second Streets, tied shut from the inside with rope. Sheriff Shirley noticed that a gas lamp was on in the window of District Attorney Bristol's office, which happened to be across the hall from the room where McCauley was being kept. Getting no answer at the door, Sheriff Shirley went to the American Hotel and stayed there until daylight. In the morning, Sheriff Shirley went back to the building and forced his way inside. There he found Hamilton McCauley swinging from a rope hung from the second floor of the building, the leg irons still affixed to his ankles.

Sheriff Shirley found Napa County sheriff McKimmey in a building across the street. Sheriff McKimmey claimed that he had been guarding McCauley when a mob had overpowered him at about 1:00 a.m. The fact that Sheriff McKimmey never named any of his attackers calls into question how hard he tried to protect his prisoner.

The coroner's inquest revealed that a mob of unidentified persons had locked up Sheriff McKimmey and broken McCauley free from his shackles and chains. The mob used a rafter in the same second-floor room where McCauley had been housed to secure the rope and end McCauley's life. No one would ever be brought to justice for McCauley's lynching. This would turn out to be the first of only two lynchings to ever occur in the Napa Valley.

CHAPTER 3
A DEBT REPAID

Joseph Warren Osborn was typical of many early Californians. He reinvented himself as the young state matured and became populated with those seeking a new start. Osborn was a commentary writer for newspapers; contemporaries praised his knowledge of agricultural and commercial matters. A Massachusetts native, by the early 1850s, Osborn was thirty-five and married with four young children. He moved his family to the Oak Knoll area of the Napa Valley and became a gentleman farmer, developing a reputation as a pioneer in agricultural experimentation and helping draft statewide laws benefiting farmers. A traveler named John Russell Bartlett who visited Osborn's farm in 1852 described it thusly: "Mr. Osborn's place was the most beautiful and picturesque in the [Napa] Valley. In fact, it was the only house wherein there was any attempt to taste and comfort; for the country was too new to expect much in this way yet."

Osborn reportedly hired farmhands from the New England region, paying them the hefty sum of seventy-five dollars a month, which was more than double the going wage being paid to local workers. Unfortunately, one of these imported workers would become a thorn in Osborn's side.

In 1863, a dispute over an unpaid debt would lead to Joseph Osborn's untimely demise. In that year, he briefly employed Charles Britton (also known as Michael Britton), a thirty-year-old Englishman, at the farm. After his term of employment, Britton relocated to San Francisco, on the promise from Osborn that his three paychecks would be forthcoming. Britton received the first two without incident; however, the third never made it

into Britton's hands. Enraged, Britton went to a San Francisco shop and purchased a brand-new six-shooter and bowie knife, apparently intent on collecting the debt one way or another.

On April 18, 1863, Britton set out from San Francisco, taking the same route that many tourists of the day did: a ferryboat ride across the bay from San Francisco and up the Napa River to the Imola area of Napa (then known as Suscol) and a stagecoach ride north to Oak Knoll. When Britton arrived at Osborn's farm, he first went to the back door of the main house, at the kitchen, and asked an Irish servant girl named Henrietta Pete if Osborn was at home. When Pete said she didn't know, Britton went to the front of the house and was greeted by Kitty Osborn, who was not quite eight years old. He asked her to summon her father from the farmhouse, and the two men walked together outside the house, with Kitty and another of Osborn's

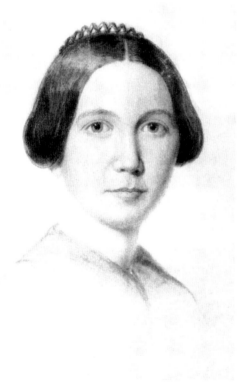

Lucretia Moore Osborn. This portrait was drawn a year after her husband was murdered. *Courtesy of Liz Adams.*

daughters watching from the front porch. What they saw next would scar them for life: as the men's conversation grew increasingly loud, Britton drew a pistol. The older daughter, only nine years old at the time, ran inside to alert her mother of the danger. As Mrs. Osborn reached the front door, she heard the sound of three gunshots ring out. She ran to her husband's crumpled body as Britton fled on foot. Osborn survived only long enough to be cradled in his wife's arms one last time as the life ebbed from his body. An autopsy later revealed that Osborn had been shot three times in the chest, one of which pierced his heart.

Britton made it about a mile from the scene of the crime

before he was stopped and detained by a band of armed citizens. Word of the shooting had spread quickly in the area, and several local farmers had armed themselves and started their own pursuit. While they waited for the sheriff to arrive, someone asked Britton about the brand-new pistol found in his possession. He remarked, "I got it for Osborn." When the sheriff asked him why he shot Osborn three times when one shot appeared fatal enough, Britton replied, "I knew I was in for it, and might as well keep on." Deputy Sheriff James Hopkins made one detour while en route to the Napa County Jail with Britton: he stopped at the Osborn farm so, in his own words, Britton could "see the blood of his victim."

In an effort to raise money for the Osborn family, local photographers compiled a book of Napa Valley scenery, advertised in Bay Area and Sacramento newspapers and donated the proceeds to the family.

At trial, Britton claimed that the killing was in self-defense. He admitted traveling to Napa with the intent to collect his unpaid debt. Britton said that when their argument turned heated, he fired a warning shot in the air. At that point, Osborn armed himself with a shovel, demanded that Britton leave his property and swung at him; Britton claimed it was only then that he fired the fatal shots.

Probably the most heart-wrenching moment of the trial occurred when little Kitty Osborn climbed onto the chair in the witness box. She recounted with vivid detail witnessing Britton shoot her father and her sister running upstairs to tell her mother.

At the end of the trial, the jury deliberated in earnest, only to become hopelessly deadlocked with eight men in favor of conviction for first-degree murder and four in favor of second degree. At the time, a first-degree murder conviction carried a mandatory death sentence, so perhaps this is the reason why some jurors were fixed on second degree. The judge declared a mistrial and speedily set a new trial date for the following Saturday. This time, the jury took only six hours to reach its verdict: guilty of first-degree murder. Reporters who witnessed the trial remarked that throughout Britton seemed "utterly callous and unmoved, like an unconcerned spectator," and was joking with spectators in the courtroom.

At Britton's sentencing, the judge made it clear that robbing the community of a useful, esteemed family man was the ultimate crime. His comments were not surprising when one considers that California was still in its infancy; robbing a society such as early California and the Napa Valley

of a productive member was unforgiveable. Britton was sentenced to be hanged by the neck until dead.

As he waited in jail for a month and a half for the sentence to be carried out, a Catholic priest attempted to minister to Britton. The clergyman reported, "He is totally depraved, and while exhorting him on grave and serious subjects, Britton will attempt to turn him aside by some frivolous remark, senseless jest or ribald laugh."

On August 7, 1863, Charles Britton went to the gallows, which had been set up in the jail's fenced-in yard. The spectacle was witnessed by several dozen citizens, as well as the jail's inmates, sending a strong message to the ne'er-do-wells. Britton refused the counsel of a priest. Before the trapdoor was sprung, he asked one request of Sheriff T.F. Raney: "Bury me as a gentleman, as I've always lived like one."

As we shall soon see, just more than ten years later, another San Franciscan would make the trek to the Napa Valley to repay a debt, but with a far different outcome.

CHAPTER 4
A WILD HORSE MURDER

Patrick O'Brien was a forty-five-year-old who had a successful tailor business in downtown Napa before buying a small piece of property in Wild Horse Valley, located four miles east of the city of Napa and bordering Solano County. O'Brien and his wife, Margaret, had three children; the oldest was his fourteen-year-old daughter, Mary Ann. In the winter of 1863, O'Brien took on an employee, James Gilbert Jenkins, to help clear some of his land in preparation for planting the spring crops. O'Brien had no idea that he was allowing a monster into his home.

Jenkins was a twenty-nine-year-old transplant from Green County, North Carolina, who had been a hired hand at local farms for several years before O'Brien took him on. He would later admit to having a long criminal history before landing in Napa County. Jenkins became smitten with Mary Ann and, within three months, proposed marriage. According to contemporary newspaper accounts, Mrs. O'Brien consented to the union; however, Patrick O'Brien was against it due to the age difference.

On January 20, 1864, Patrick O'Brien left the homestead early in the morning to clear some brush near the house. It just so happened that on the same date Jenkins went to the neighboring property of the Sanders family; he borrowed a rifle and some shells from Mrs. Sanders, claiming that he needed them to shoot some deer. He came back several hours later and returned the rifle, explaining he couldn't find the deer; Mrs. Sanders reported that when he came back, Jenkins was sweating profusely, seemed excited and turned down her offer to stay for dinner, instead rushing out of the house.

Later, when Mary Ann O'Brien called out for her father and Jenkins to return home for supper, Jenkins came straight away, but Patrick was nowhere to be found. Jenkins went outside and yelled repeatedly for Patrick as well, with no answer. A massive search was launched by neighbors, with Jenkins helping in the effort. Those familiar with how offenders work will tell you it is somewhat common for offenders to insert themselves into investigations, such as participating in search efforts. Jenkins would later claim to have already searched a particular area near the house, thereby diverting the other searchers. The searchers continued well into the night, bolstered by a report from a neighbor of hearing a gunshot in the direction of the O'Brien farm; their efforts were in vain.

Suspicion immediately fell on Jenkins because of his well-known desire to have Mary Ann to himself and the fact that he had borrowed the rifle on the same day as O'Brien's disappearance. When O'Brien still hadn't been found by Sunday, the neighbors detained Jenkins and took him to Napa, turning him over to the sheriff. Jenkins was held overnight on the authority of a justice of the peace; however, without a dead body, the district attorney felt he couldn't prove a murder had occurred and had no choice but to order Jenkins's release. Even today, with modern forensics and investigative techniques, these types of cases, known as "no body" homicides, are exceedingly difficult to prove in court.

A week after Jenkins's release, Patrick's body was found by searchers when a dog became excited by an area of freshly turned-over dirt. Patrick was buried in a shallow grave, concealed under some brush, not three hundred yards from his home in an area that Jenkins claimed he had searched. Boot prints found near the body led into a canyon toward the Sanders farm. The boot prints showed that the person who made them was walking from the Sanders farm and was running on the way back. The boot prints were later matched up to Jenkins's boots, and he was quickly rearrested.

The sheriff, county doctor and other officials rode to the site of the body. Based on the condition of the body, they decided it was unwise to move it, so the autopsy was performed in the field. The autopsy revealed that O'Brien was most likely stooping over, clearing brush, completely unaware of Jenkins's intent. A single rifle shot entered O'Brien's lower back and traversed upward, lodging in his jaw. The weight of the slug recovered from O'Brien's body matched the ammunition from the rifle that Jenkins had borrowed from Mrs. Sanders.

Jenkins went to trial a week after the body was discovered. One of his friends, T.A. Saunders, testified that a few days before the killing, Jenkins had told him that he feared that Patrick would block his pending marriage plans with Mary Ann and asked to borrow Saunders's pistol; Saunders refused, an action that apparently caused Jenkins to turn to "plan B." It took the jury only fifteen minutes to decide Jenkins's fate: guilty of first-degree murder. Jenkins showed no reaction as the verdict was read; the *Napa Register* newspaper reported that Jenkins "looked more like a statue of marble than a living man." The judge set March 18, 1864, as the date for his execution. The only comment Jenkins had was, "I wish it was tomorrow; I don't want to wait so damned long."

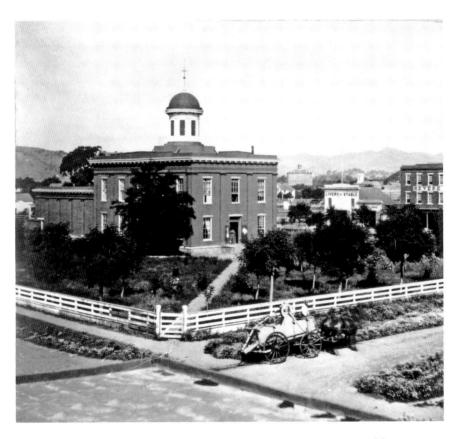

The Napa County Courthouse as it appeared during the 1863 murder trial of James Jenkins. The courthouse was later condemned due to structural issues and replaced in 1879. *Courtesy of the Society of California Pioneers.*

The jailer would later report that while incarcerated, Jenkins sang and jested and appeared unmoved by his impending demise. While in jail, Jenkins struck up a friendship with former sheriff Charles Allen, who agreed to write down Jenkins's account of his life of crime. In this missive, Jenkins claimed to have killed more than eighteen men and committed various other robberies and petty crimes throughout the Midwest and South. The "story," a dime novel of sorts, was later sold at a local stationery store.

Later suspicion would fall on Jenkins for several other unsolved murders that had happened in the Wild Horse Valley area during the years Jenkins worked as a farmhand, although no firm evidence was ever uncovered.

On the date of his execution, Jenkins left his jail cell and climbed the same set of gallows that had one year earlier dealt justice to Charles Britton. The gallows were set up in the enclosed yard of the county jail. At just past 3:00 p.m., the trapdoor was sprung. Jenkins's heart stopped beating thirteen minutes later, and he was lowered into a plain pine box. A newspaper reporter who followed the crime described Jenkins as "a man of strong though uncultivated intellect and great energy and firmness of purpose, but completely callous to human suffering and as ready to kill a man as a dog, if it suited his purpose."

Jenkins would go on to become known as the Napa Valley's first serial killer and was the last man hanged in the valley until 1897.

CHAPTER 5
BRANNAN BITES A BULLET

S am Brannan was truly larger than life. His influence on early San Francisco, the city of Calistoga within the Napa Valley and Northern California cannot be overstated. Brannan first came to California in 1846, part of a group of Mormon settlers sent by church leader Joseph Smith to establish a settlement. They landed at the Mexican port of Yerba Buena (present-day San Francisco), effectively tripling the population of the settlement by stepping off the boat. Brannan is credited with establishing the second English language newspaper in Northern California, the *California Star*, which would later combine with the first (based in Monterey) to become the *Daily Alta California*, one of the key sources used for many of the stories in this book.

Brannan would prove himself to be a better entrepreneur than church devotee; he jumped headlong into the gold rush frenzy of 1848. Brannan was collecting tithes from church members at Sutter's Mill, in the California foothills, when he learned about the recent gold strikes in the foothills. He rushed back to San Francisco and used the collected tithes to corner the market on shovels in the city, making a fortune off the eager miners who began arriving by boat daily. He went on to open successful supply stores in both San Francisco and at Sutter's Fort in Sacramento, the two main jumping-off points for gold miners headed into the gold fields.

Brannan also established the first school in San Francisco, was elected to the city's first town council when California received statehood and helped form San Francisco's Committee of Vigilance, a group that operated as a pseudo police force, detaining and interrogating people, rousting houses of

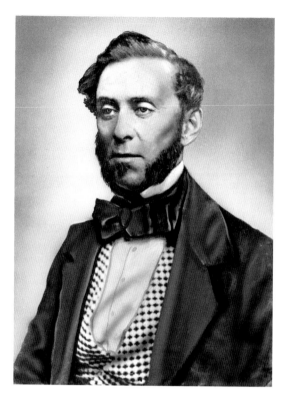

Samuel Brannan was a
Mormon pioneer, entrepreneur
and founder of Calistoga.
*Courtesy of the Church History
Library, the Church of Jesus Christ
of Latter-day Saints.*

ill repute and hanging people they deemed guilty. It was his part in vigilante executions and accusations that he funneled Mormon tithes to finance his own enterprises that led to Brannan being disfellowshipped from the Mormon Church.

By the time Brannan arrived in the Napa Valley in 1859, he had added land speculator in Hawaii and California state senator to his résumé. Brannan immediately recognized the potential of the natural hot springs in the northern part of the valley. He bought a swath of land from pioneer settler Edward Bale and founded the town of Calistoga as a location to build a world-class resort. Brannan would later add the property formerly owned by William Hargrave and Henry Fowler, one of the sites of the 1850 Indian massacre mentioned earlier. The famous legend of how Calistoga was named says that during a dinner party that included copious amounts of alcohol, Brannan remarked that he would make a "Calistoga of Sarifornia," actually intending to say "Saratoga of California," referring to a then-famous spa resort in New York State.

Brannan would impact more than his resort town; he founded and built the Napa Valley Railroad as an easy way to get tourists from the ferry docks in the southern part of the valley north to Calistoga. The tracks he laid would go on to service freight trains transporting the fruits of the valley's labors and later served as the right of way for a commuter electric railway that followed years later. Today, the same tracks carry a different kind of cargo: trainloads of tourists riding on the Napa Valley Wine Train.

By 1868, Calistoga was fully developed, complete with cottages owned by luminaries from San Francisco society, a dance hall, a horse-racing track and stables, a fine restaurant and hot springs pools. Brannan leased part of his property to Warner Buck to construct a sawmill. Soon thereafter, Buck went bankrupt, and the mill passed to one of his creditors, A. Snider. Brannan initially was given possession of the mill by the county sheriff; however, he left it unguarded and unoccupied, so Snider and some of his workers decided to squat on the property. This didn't sit well with Brannan, who rounded up a few confederates, armed them with pistols and headed over to the mill to forcibly evict the Snider group. It's unclear why Brannan didn't enlist the help of the courts or the sheriff to deal with the issue, unless you consider the character of Brannan: he was a man of action.

On the evening of April 17, Brannan and his force of men went to the mill to take action. Brannan and one other man started walking to the mill's entrance while the others waited by the fence line. Brannan demanded that Snider vacate the mill, but Snider refused. Brannan then promised to return the next morning to finish his eviction. In response, three or four shots rang out from the mill, striking Brannan's partner. Snider allegedly then yelled, "Blaze away boys!" According to newspaper reports, as many as twenty shots were fired in a volley from Snider's group. A shotgun blast found its mark on Brannan, with one ball entering his neck, one his shoulder and one his kidney. Brannan's injuries were treated by a doctor from Napa and a second one who was brought in by train from San Francisco on the same train that Brannan financed. Brannan's wounds were serious but not life threatening.

A week after the shooting, a preliminary hearing was held in the town of St. Helena in front of Justice of the Peace Clark. After hearing the testimony, Judge Clark released Snider and the four members of his party who had been arrested. Based on published reports in the newspapers of the time, it appears that public opinion placed blame with both parties: Brannan for trying to strong-arm the squatters off his property and Snider's group for

responding with bullets. It appears no further criminal charges were filed; the district attorney probably had doubts about finding twelve impartial jurors who would convict.

As if the shooting were a foreboding sign, within a year of being shot, Brannan's fortunes turned: his wife filed for divorce, taking half of his assets. Several years later, he leased his resort in Calistoga, and then the bank took it away when he defaulted on loans. The resort that Brannan had put his heart and soul into was parceled out and sold bit by bit; parts of it today still are home to Calistoga's thriving spa resorts. One of Brannan's original cottages survived and is on display at the Sharpsteen Museum of Calistoga History, located in the town Brannan founded.

Sam Brannan himself moved to San Diego County and became an alcoholic. He tried several times to reignite his entrepreneurial spark by speculating on land near the Mexican border; however, when he died in 1889, he was nearly penniless.

Most biographies on Brannan ignore or overlook his near-death experience at the mill in Calistoga. Even the founder of Calistoga could not avoid the violence that punctuated the bucolic peace of the Napa Valley.

CHAPTER 6
A FILM PIONEER WHO PACKED A PISTOL

In order to understand what brought one of the most famous photographers in the West to the doorstep of a remote quicksilver mine outside Calistoga in the middle of the night with a gun in his hand, one must first understand the characters in this tragedy.

Numerous books have been written about the life and professional accomplishments of Eadweard Muybridge, and rightly so. He is now known as one of the pioneers who blazed the trail to modern motion pictures that we all take for granted today. Muybridge was born in Kingston-upon-Thames, England, in 1830. His birth name was Edward James Muggeridge, a name he would change several times over his lifetime. He changed his first name to Eadweard, most probably due to the 1850 discovery of a historic inscribed stone near his birthplace that spelled several Saxon kings' names as "Eadweard." Around the same time, he changed the spelling of his last name to "Muygridge." His first profession was a bookseller. In 1851, Muybridge set out for the New World, setting up shop in New York City as a commission merchant. Muybridge would import unbound books from England and then bind and sell them.

In 1855, Muybridge uprooted his business and started anew in San Francisco, building a successful store that dealt in all varieties of books. He became a prominent member of the intellectual community that had sprung up in the city after the tumult and growing pains of the gold rush years.

In the summer of 1860, Muybridge began what was to be a cross-country stagecoach ride to the East Coast, with plans to continue on to England

to secure more literary business, leaving his shop in the care of one of his brothers. Somewhere near the Brazos River in Texas, the horses pulling the stage went wild, causing the stage to overturn. Muybridge was thrown head-first into a boulder. Perhaps he was lucky, since one of the other passengers was thrown from the stage and killed. Muybridge was in a coma for four days, lying in a Texas hospital without any identity. Later, speculation would center on whether this injury caused long-term mental health issues. People who knew him before and after the accident reported that afterward he had a shorter temper and became careless in business matters.

There was a six-year gap in Muybridge's documented biography, during which time he reinvented himself, traveling back to England and honing his skills at photography. Photography was rapidly developing during this era with the advent of the stereoscope, a device that allowed the viewing of two identical photographs side by side from slightly different angles, creating a 3-D illusion. The stereoscope was particularly powerful when viewing landscapes. When he resurfaced in San Francisco in 1866, Muybridge had changed his last name from Muygridge to Muybridge and taken the pseudonym "Helios" for his photographic pursuits. He would become known as one of the first photographers to train their lenses on the pristine Yosemite Valley.

It was during this period that Muybridge was introduced to then-governor Leland Stanford. The governor, an avid racehorse owner, was researching the mechanics of horse motion in hopes of improving the training methods for his horses. In 1872, Stanford hired Muybridge to take still photographs of one of his horses at full gallop, proving the theory that all of a horse's hooves are off the ground at certain points during a gallop.

Muybridge first met his future wife, Flora Stone, one year earlier in 1871. She was working as a photographic retoucher at the time. When they married a year later, she was all of twenty-one and Muybridge was forty-two. Flora had come to California from Alabama when she was thirteen, in 1864. Both her parents were dead, and her grandparents consented to letting her live with an aunt in the city of Marysville. She later was cared for by a foster father who sent her to a well-respected school for girls during her later teen years. When she met Muybridge, Flora already had one failed marriage to another older man under her belt. The couple would live uneventful married lives for two years—until Harry Larkyns came into their world.

Harry Larkyns's history is a bit sketchy and no doubt was learned by his contemporaries in San Francisco from Larkyns himself, calling into doubt

A Film Pioneer Who Packed a Pistol

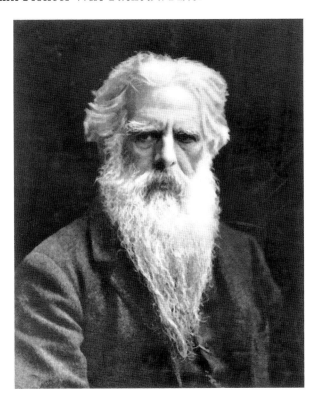

Photographer and film pioneer Eadward Muybridge. *Courtesy of the University of Pennsylvania Archives.*

how much of it was true. Such was the nature of the early West, especially for a foreigner; it was fairly easy for someone to reinvent himself. Published accounts of Larkyns's life read like an action-adventure movie. Larkyns was born around 1845 to a respectable and wealthy family in England; he apparently squandered his inheritance and entered the British army, serving for several years in India. Later, Larkyns volunteered and serve in the French army during the Franco-Prussian War of 1870–71. It was during this war that he was commissioned as a major, a rank that he would use the rest of this life.

Larkyns arrived in San Francisco early in 1873. He almost immediately got into trouble, allegedly defrauding an investor of $3,000 he was given to arrange an around-the-world excursion. Larkyns was charged with obtaining money by false pretenses and passing a fictitious check. He was able to buy his way out of trouble by getting his grandmother back in England to pay off the debt. After the fraud incident, Larkyns took several odd jobs, including working at the wharves and as a translator for a publishing house. He then

found his calling: working as a freelance writer for several local newspapers, reporting as a drama critic.

Larkyns made an impression on everyone who met him; an article in the *San Francisco Examiner* from the time described him as follows:

> *He was every inch a Bohemian and debonair man of the world. He spoke divers tongues, all equally as he did English...He could box like Jem Mace, and fence like Argamonte...He could hit more bottle necks with a pistol at twenty paces than anyone else...Larkyns was over six feet tall, straight as a fence, and had the gift of spreading a ripple of sunshine wherever he went. His wit and clever stories and general affability won him a legion of friends.*

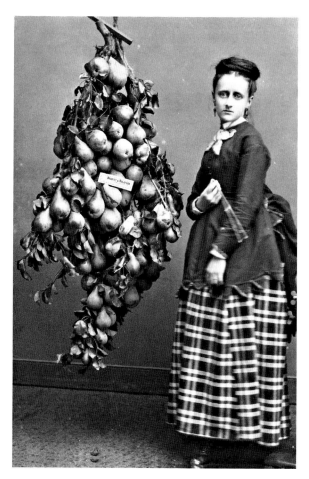

Flora Muybridge, photographed while pregnant, in 1873. The bough of pears pictured with her is meant to be a sign of fertility. *Courtesy of the Iris & B. Gerald Cantor Center of Visual Arts at Stanford University.*

A Film Pioneer Who Packed a Pistol

It was in his position as a drama critic that Larkyns's path crossed the Muybridges'. Larkyns helped Muybridge design the newspaper ads that he used to sell his collections of photographs. Larkyns began escorting Flora to theater performances and was seen around town riding horses with her. During Muybridge's extended absences for photographic location shoots, Larkyns began a romantic affair with Flora.

In the fall of 1873, Flora announced to her husband that she was pregnant. Muybridge was out of town when his son, Floredo Helios Muybridge, was born. The nurse chosen by Muybridge to help Flora care for their son was named Susan Smith; she would wind up becoming a messenger of sorts, carrying information between Flora and Larkyns about when it was safe for Larkyns to visit.

The affair first came to light sometime in 1874, when Muybridge walked in on Flora and Larkyns engaged in an embrace. Muybridge forbade Larkyns to ever contact Flora again, threatening to kill him if Larkyns did so. Whether because of the threats from Muybridge or just because he wanted a change of scenery, Larkyns took a job as a field correspondent for a small newspaper and started doing surveying work in the Napa Valley for the mines that dotted the hills above Calistoga. His last job was working at the Yellow Jacket quicksilver mine. Muybridge sent Flora, the baby and Susan Smith off to stay with Flora's uncle in Oregon. While Flora was away, Smith continued to pass letters back and forth between Flora and Larkyns.

The beginning of the end was on October 14, 1874. Smith had sued Muybridge for a $100 payment for services rendered while in Oregon. Muybridge refused to pay, claiming the debt had already been settled. In order to prove her case, Smith turned over several letters to her lawyer that Flora had written; the letters would later become known in the San Francisco newspapers as the "guilty letters." It was then that Muybridge learned that Larkyns had ignored his warning to stop communicating with Flora.

Three days later, Muybridge directly confronted Smith, demanding the whole truth about the relationship. He learned that Floredo wasn't his son but had actually been sired by Larkyns. This was confirmed for Muybridge by means of a photograph, one of Floredo that Flora had sent back to Smith in San Francisco. On the back of the photograph, Flora had written "little Harry" (referring to Larkyns's first name). This was the proverbial straw that broke Muybridge's back and sent him into a rage, causing him to fall to the floor in such a fit that Smith later reported that she thought he might die on the spot.

Instead of dying, Muybridge collected himself and went to the Bradley and Rulofson photography gallery in San Francisco. He gave his friend Rulofson the "guilty letters," asking him to hold on to them until Muybridge returned or burn them if he died. Muybridge then went to his own office with Rulofson in tow and collected a pistol from his desk. Rulofson tried to distract Muybridge so that he would miss the afternoon ferry from the city across the bay to Vallejo and then tried to physically restrain him. Muybridge broke free and sprinted the few blocks to the ferry terminal. By 6:00 p.m., Muybridge was in Vallejo, where he transferred to the northbound train. He got to Calistoga by 7:30 p.m.

Muybridge went to the livery stable and tried to rent a horse and buggy. The owner was concerned about the late hour and the dangerous conditions of the roads leading up to the mines. Muybridge would not be dissuaded, so the owner agreed to let a stable boy, George Wolfe, drive Muybridge. During the trip, Muybridge pretended to be concerned about the threat of robberies and asked Wolfe if he could test fire his pistol without the horses being spooked. With Wolfe's consent, Muybridge shot once into the air, ensuring that his pistol was ready for action.

When they arrived at the superintendent's house at the Yellow Jacket Mine where Larkyns had been working, a party was in progress. Muybridge asked Wolfe to stay with the buggy and then climbed the steps to the front porch and knocked on the door. The mine foreman, Benjamin Pickett, answered and, at Muybridge's request, summoned Larkyns from an ongoing card game. Larkyns approached the doorway and asked who it was, since the lights from inside the residence caused Muybridge to be hidden in the shadows. Muybridge responded, "Good evening, major. My name is Muybridge. Here is the answer to the message you sent my wife!" A single gunshot rang out, striking Larkyns in the chest and killing him instantly. Muybridge then entered the residence and surrendered to the stunned onlookers.

Muybridge was transported in the same buggy he had hired to the jail in nearby Calistoga. During the trip, he freely admitted to his guards the sordid details that had led him to kill Larkyns and that he had planned the killing as retribution. He was jailed there until the following Monday, when he was arraigned in front of the town's justice of the peace, Justice Palmer. Muybridge waived his preliminary hearing and was taken to the county jail in Napa to await the findings of the grand jury. In December, the grand jury returned an indictment of murder in the first degree; Muybridge entered a plea of not guilty by reason of insanity.

A Film Pioneer Who Packed a Pistol

The case created an immediate sensation throughout Northern California and beyond. A reporter from the *San Francisco Chronicle* named George Smith obtained a jailhouse interview with Muybridge, in which he recounted the events that led him to kill Larkyns. Muybridge used Smith to correct some of the erroneous information that had been swirling around the social circles and newspapers.

Eadweard Muybridge's trial began in February 1875. The magnitude of the case—or, more accurately, the magnitude of the personalities involved—led District Attorney Dennis Spencer to seek assistance on the prosecution team, enlisting the aid of a District Court judge named Thomas Stoney. Muybridge's defense team came from San Francisco and was led by a state senator named W.W. Pendergast. Instead of a District Court judge presiding over the trial, William T. Wallace, the chief justice of the California Supreme Court, was tapped to run the show.

The trial itself was relatively straightforward. There was no argument about the crime itself or about Muybridge's motive. The defense attorneys painted Muybridge as dealing with a "villain." They then painted Muybridge as being "disturbed" and suffering from temporary insanity during the crime, calling business associates and acquaintances from San Francisco who described him as eccentric, easily excited, nervous, irritable and careless with money. One witness pointed to an incident in which Muybridge perched himself on the edge of Half Dome in the Yosemite Valley to take a photograph as showing that he was insane. The prosecution countered with the testimony of Dr. G.A. Shurtleff, who was at the time the superintendent of the Stockton Insane Asylum. Shurtleff said that based on Muybridge's actions leading up to the murder, his opinion was that Muybridge was sane at the time of the shooting.

The prosecutor perhaps made his biggest blunder at the end of the trial. During his closing argument, Stoney urged the jury to return a verdict of guilty of first-degree murder; he brushed off any lesser charge such as manslaughter and said, "Make it what it ought to be, or nothing." He went on to describe Muybridge as a man of "culture, genius, and intelligence." The lead defense attorney, W.W. Pendergast, delivered an eloquent defense of Muybridge, invoking the Bible and entreating the jurors to allow Muybridge to "take up the thread of his broken life and resume that profession upon which his genius has shed so much luster—the profession which is now his only love." The applause in the courtroom as Pendergast sat down was a bad omen for the prosecution.

The jury deliberated for thirteen hours before returning a verdict of not guilty. Newspaper reporters in the courtroom reported that Muybridge had a "paroxysm," an outburst of emotion. He fell into the arms of his attorney, weeping and convulsing. He was carried briefly to the nearby office of his attorney and a doctor was called, although he recovered his composure soon thereafter and took the first boat back to San Francisco.

Public sentiment was squarely in Muybridge's corner. Several jurors later reported to the *San Francisco Chronicle* that they would have done the same thing if someone seduced their wife. The *Napa Daily Register* applauded the verdict as a warning to potential adulterers.

After the trial, Muybridge subjected himself to a self-imposed exile in Central America and Panama for a year, working for a steamship company to photograph the local fauna and scenery. While Muybridge was away, his wife, Flora, tried unsuccessfully several times to divorce him and obtain alimony. She died on April 18, 1876, at the age of twenty-four. Her last words were reportedly, "I am sorry."

Upon his return to San Francisco, Muybridge sought out Flora's son, Floredo, who was being cared for by a French family. He transferred Floredo to an orphans' asylum, and although he considered Floredo the son of Flora and Larkyns, he still gave Floredo his last name and visited him several times during the ensuing years.

Back in San Francisco, Muybridge took a series of photographs of the city from the tower of railroad magnate Mark Hopkins's residence on tony Nob Hill. He stitched the photographs together to form a panorama of the city and sold the series in book form. These would later serve as valuable historic references, especially after the devastating 1906 earthquake and fires.

In 1879, Muybridge invented a device he called the Zoopraxiscope; it allowed a viewer to see a series of still photographs that were mounted on a circular glass disc. As the disc spun in front of an illuminating lantern, it created the illusion of motion when viewed in the Zoopraxiscope. Muybridge used the photographs of a horse at full gallop that he had taken for Leland Stanford; he later used other images, such as a man sprinting and jumping over hurdles, nude Greco-Roman wrestling and even a series of photographs of a nude man ascending and descending stairs (with Muybridge himself acting as the model).

Muybridge gained wide acclaim for his work with the Zoopraxiscope, taking it on the road for a tour of Europe. In 1893, Muybridge's work reached

its pinnacle as he traveled to the World's Columbian Exposition in Chicago. He erected a building on the midway, dubbing it the Zoopraxigraphical Hall. Some would later call it the first motion picture theater in the world.

Muybridge then retired to his hometown of Kingston-Upon-Thames, where he died in 1904. His legacy as pioneer of motion pictures is still recognized today. In 2012, on the 182nd anniversary of his birth, the Internet web search site Google changed its masthead logo into an interactive version of Muybridge's famous Zoopraxiscope series on galloping horses.

CHAPTER 7
THE SUICIDE THAT WASN'T

As the Napa Valley prepared for a quiet Christmas in 1881, the calm and cheer of the season was upended by the headlines in the *Napa Daily Reporter* that announced the suicide of twenty-one-year-old Edward Butler at the Occidental Winery, located near the town of Yountville. Butler had been found on the floor of the winery with an apparent gunshot wound at his temple. The county coroner, Frederick Coleman, immediately called for a coroner's inquest. This was a standard practice in this era: the coroner would impanel an inquest panel of ordinary citizens and present to them the evidence collected during the autopsy and from the scene, and the panel would rule on the decedent's cause of death and, if appropriate, who was responsible. These inquests were typically held within a day or two of the death, primarily due to the fact that funeral homes lacked the ability to store bodies for any length of time. In this case, the rush to judgment would come back to haunt Coleman. In the Butler case, the coroner ruled that Butler committed suicide while laboring under a fit of insanity.

The scene of Butler's death was one of the premier wineries in the Napa Valley at the time. The winery was the brainchild of Terrill Grigsby, who came to the Napa Valley in 1852. Grigsby's first foray into the wine industry was leasing some vineyards north of Yountville. In 1878, he bought eighty acres of land east of Yountville in the area that straddles the current Silverado Trail. The area Grigsby chose would later become known as the Stags Leap AVA (a designated viticulture area within the valley). Grigsby used Chinese laborers to build the initial winery building, a wooden structure. The first

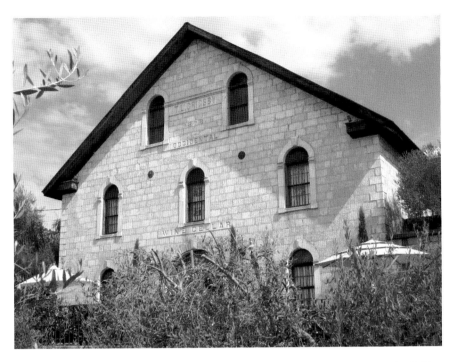

The Grigsby-Occidental Winery appears today as it did when it was first built in 1878 by Terrill Grigsby. The building is currently the centerpiece of the Regusci Winery. *Author's collection.*

building burned to the ground shortly after it was completed, allegedly at the hand of an unknown arsonist. Undeterred, Grigsby built a grand three-story winery on the site, this time solidly built with lava stone and two-foot-thick walls. It was within these walls that Butler's life ended.

The day after the coroner released Edward Butler's body, the undertaker made several key discoveries that had been overlooked at the inquest: first, the supposed bullet hole on Butler's temple was actually made by an edged instrument. Second, a bullet hole was in the back of Butler's head. Lastly, the area around the bullet hole lacked any powder burns, which tended to show that the gun that had delivered the fatal shot wasn't close to Butler when it was fired, discounting the suicide theory.

Butler's father was the driving force behind finding his son's killers. He hired two private detectives from San Francisco named Hamilton and Avau to investigate the case. They came to the valley a week after Butler's death and worked with Undersheriff Brown to question workers at the winery and look at the scene of the death again. As a result of their efforts, two Chinese

workers, Chin Ah Loy and Wah Ah Wing, were arrested. The investigators discovered bloody clothing belonging to Loy and Wing and a hatchet used during the assault.

The white residents of the Napa Valley had long maintained an uneasy relationship with Chinese settlers. The presence of the Chinese in large numbers in the Napa Valley dated back to the construction of Sam Brannan's Napa Valley Railroad in 1864. They were also instrumental in the excavation of many of the valley's original wine caves. The valley's farmers and winery owners quickly learned that the Chinese were also skilled at agriculture, and they formed a core group of much-needed laborers. In addition, Chinese workers took jobs as household servants and cooks, ran laundries and worked in the quicksilver mines. There were plenty of Chinese in the state, most of whom had come during the gold rush era; they came by enlisting with one of a handful of Chinese "companies" that sponsored their travel in exchange for a share of any wages they earned.

The Chinese created settlements in several towns in the valley. The largest, perhaps numbering as many as six hundred people, was at the edge of the town of St. Helena. This settlement displayed the love/hate relationship

A *Harper's Weekly* lithograph from 1878 depicts Chinese workers engaged in winemaking in the Napa Valley. *Author's collection.*

many early Californians had with the Chinese. The local newspaper, the *St. Helena Star*, ran several articles railing about the "celestials" for their perceived poor hygiene, drug usage and other stereotypes. Some citizens in St. Helena even founded an Anti-Coolie League in an effort to run the Chinese out of town.

Napa's Chinatown was located in the area of First Street east of Main Street on a spit of land that jutted out into the Napa River where the Napa Creek joined it. Today, the only remnant of that area is the badly eroded spit of land, which is now known as China Point. At its height, Napa's Chinatown had about five hundred people living in it. The area was made up of wooden structures, some on stilts to combat the frequent flooding that plagued the area. It featured shops to serve the populace, as well as a joss house/Taoist temple, opium dens, gambling houses and brothels. Besides flooding, Napa's Chinatown also fell victim to periodic fires. It burned to the ground at least twice, in 1902 and in 1920. The 1920 fire sealed the area's fate; the settlement was never rebuilt, partially because of its perceived reputation and partially because the town fathers wanted to build a yacht club at the site.

In March 1882, Chin Ah Loy cheated justice by hanging himself in the Napa County Jail. The *Napa County Reporter* noted that Loy had secured a length of silk rope to a grate in his cell's ceiling, climbed on top of his slop bucket and literally "kicked the bucket" to complete the act.

Just before his trial was scheduled to begin, Wah Ah Wing tried to follow his cohort's example by hanging himself in his cell. Unfortunately for Wing, an alert jail guard noticed him and cut him down before he could complete the act. The next month, Wing went on trial for Butler's murder. One of the most damning witnesses was a jailhouse informant named Chew Check; the San Francisco detectives had hired Check at one of the Chinese-American societies in San Francisco and placed him in the Napa County lockup to gather information from the murderers. The investigators had placed a white interpreter in an adjoining cell, and he overheard both Loy and Wing confess to the murder. Loy and Wing explained that Butler's father supposedly owed them some money and they had gone to Butler to collect it. Butler told the men that his father would be returning shortly from San Francisco with proceeds from the sale of some wine and could pay them then. Loy and Wing accused Butler of trying to cheat them out of their money, and Butler threw them out. A short time later, Loy and Wing returned. They claimed

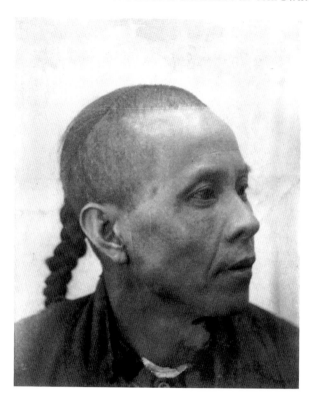

Wah Ah Wing's 1882 booking photograph from San Quentin State Prison. The handwritten note indicates he was discharged from custody in 1890 after serving eight years. *Courtesy of the California State Archives.*

that Butler drew a pistol and tried to shoot them and that a struggle then ensued, during which Wing struck Butler on the head with the hatchet.

The defense apparently was surprised that Check was a witness and could not directly refute his testimony or that of the interpreters who verified it. Instead, the defense team still clung to the theory that Butler had committed suicide by pointing out supposed character flaws in Butler to prove his insanity. The jury didn't buy it; they deliberated overnight and returned a verdict of guilty to the charge of second-degree murder the following morning. Wing was sentenced to ten years at San Quentin State Prison. Prison records indicate that he was released in December 1890 after serving just over eight years.

CHAPTER 8
WINERY OWNER'S TRAIN TRAGEDY

There are many famous names associated with the early wine industry in the Napa Valley, such as Fredrick and Jacob Beringer, Charles Krug and Gustav Niebaum. One name that sometimes gets overlooked is that of John C. Weinberger, perhaps because his life was cut short in a tragedy that rocked the valley. Weinberger was a native of Germany who immigrated to the United States in 1848. He initially practiced the family trade as a confectioner, both in New York and later in Indiana, where he also planted a fruit orchard. In 1869, Weinberger took a trip to California and was so impressed with the Napa Valley climate that he decided to move out west with his wife, Hannah, and daughter, Minnie. He purchased 240 acres just north of St. Helena from Dr. Edward Bale, one of the upper Napa Valley's pioneers. Weinberger planted vineyards as well as fruit orchards. He became known not only for his wines but also for grape syrup, which he pioneered as a byproduct of the harvest. He was a pillar of the early community of St. Helena, serving as the treasurer of both the local Masonic Lodge and the Grange, and was a founding member of the Bank of St. Helena.

Weinberger was known for his business acumen and courage. Shortly after coming to California, he was the passenger in a stagecoach that was robbed on a route between Los Angeles and San Bernardino. Weinberger drew a Colt revolver he had hidden under his coach seat and shot one of the robbers, forcing him to run off. Weinberger then shot the other robber who was standing in front of the stage; the commotion allowed the stagecoach driver to pilot the stage to safety. Once alerted to the attempted robbery, the

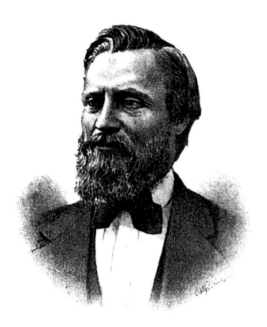

Winery owner John Weinberger as he appeared shortly before his murder. *Author's collection.*

local sheriff went back to the scene of the crime to find one bandit dead and the other cowering in the bushes, badly wounded.

On March 20, 1882, Weinberger was working on the hillside portion of his vineyard property when he received a telegraph supposedly from a San Francisco wine buyer known to him asking Weinberger to meet at the Lodi Lane train station just north of St. Helena. Weinberger hopped into his buggy and drove down to the station, stopping just short of his destination to leave his horse and buggy with L.P. Castner, fearing the horse might be spooked by the coming train.

When the morning train arrived, Weinberger was surprised to see not the wine buyer but William J. Gau step off the passenger car. Gau was wearing a top hat and long overcoat. Gau was a former employee of Weinberger's who had left under less than friendly terms. It seems Gau became enamored with Weinberger's daughter, Minnie, a pairing that the Weinbergers refused to allow, probably due to Gau's low station in life. Gau went so far as to publish an engagement notice in a newspaper in San Francisco. This was the final straw; Weinberger fired Gau but did give him severance of several hundred dollars. The money did nothing to assuage Gau's hatred of Weinberger, and he made several threats against his life.

Winery Owner's Train Tragedy

Witnesses later reported that at the train station, Weinberger seemed to want to avoid an argument with Gau, turning his back on Gau and trying to find the wine buyer who had summoned him. Weinberger had no way of knowing that the telegram was a ruse by Gau. Gau used this opportunity to walk up directly behind Weinberger, drawing a Smith & Wesson revolver. The train started to pull away, masking the warning yells of his friend Castner, who witnessed Gau's treachery. When Weinberger finally turned to Gau, he came face to face with a pistol. Gau immediately fired, the first shot entering Weinberger's mouth. As Weinberger began to fall, Gau fired a second time, this bullet entering Weinberger's head near his right ear. His task complete, Gau put the pistol to his own head and fired, this final bullet entering the side and exiting through the top of his head, punching a hole in his top hat and ending his life just after the life had ebbed from his target. Bystanders collected Weinberger's lifeless body and rushed it to his house; however, as the *St. Helena Star* reported, "the carcass of the worthless murderer was left on the ground." Such was the contempt felt toward Gau.

A lavish funeral was planned for Weinberger by members of the Masonic Lodge. Pallbearers included fellow winemaking pioneers Charles Krug and Jacob Beringer. The choirs from multiple denominations in St. Helena joined together for the tribute.

The untimely demise of her husband thrust the now-widowed Hannah Weinberger into the spotlight. She stepped into her husband's shoes, taking over the reins of the couple's beloved winery and, in doing so, becoming the first woman to run a winery in the Napa Valley. She was an able owner, as evidenced by the fact that one of her cabernet sauvignons won a medal at the 1889 World's Fair in Paris, a first for a California wine and an event that thrust the Napa Valley into the forefront of American winemaking. Hannah was apparently an able organizer as well, as she took over her late husband's seat on the board of directors of the Bank of St. Helena. Hannah would continue to run the family winery until 1920, when it was finally shut down not by mismanagement or lack of sales but by Prohibition.

When Hannah died at age ninety-one in 1931, the family sold off the bulk of the winery's acreage but kept the residence and winery itself. Today, the house and winery are owned by the Ballentine family, who run William Cole Vineyards; the Ballentines still have a buggy owned by the Weinbergers—perhaps the one that John Weinberger piloted toward his date with death 130 years ago.

CHAPTER 9
THE LAST LYNCHING

In the early years of the county, there were more than a few desperados who never made it to trial for their alleged crimes, instead finding "justice" at the end of a rope administered by vigilantes. While taking the law into one's own hands is seldom thought of today, one has to remember the climate of the late 1800s and the character of the people who took the leap of faith to populate the frontier of California. At the time, people were adept at being self-reliant. To paraphrase it, they "took care of business."

A band of citizens in St. Helena took these measures in 1888 in what would be the last lynching to occur in the Napa Valley. The desperado was one John "Jack" Wright, an eighteen-year-old being held for the murder of Robert "Bud" Vann. Wright was reported in the local newspaper to be a "hanger-on at a house of ill-fame." The Vann family was one of the most respected in the upper Napa Valley. The family patriarch, Michael Vann, had earned a reputation as a pioneer in viticulture; he and a group of four or five other farmers were the first to use cuttings provided by John Patchett to plant grape vineyards, which would become synonymous with the Napa Valley. He was also a founding trustee of the local Vineland School. Bud, twenty-nine at the time of his death, was the fourth of Vann's sons and was well liked with a good disposition.

On April 21, 1888, Bud and a friend named John Greer went into St. Helena for a night of revelry. They got to a saloon located on Railroad Avenue, just east of the train station, at about 11:00 p.m. The building was a two-story structure that was common of many saloons of the time; it had

a saloon on its first floor and a brothel on the second story. Bud and Greer had a few drinks. Bud decided he wanted to play around with a sewing machine that was set up in the saloon. One of the infamous women who plied her craft at the saloon, Sadie Marion, took offense to Bud's action. She told him to stop, and when her words had no effect, she grabbed a chair and attempted to break it across Bud's head. Bud blocked the blow and pushed Sadie back, whereupon she pretended to faint. Bud and Greer decided this was a good time to leave the saloon. A few hours later—and a few more drinks later, no doubt—Bud and Greer started the long walk home and met up with a friend, John Maloney. They recounted their exploits at the saloon to Maloney. Unfortunately, Maloney also had a few drinks in him and convinced his friends to reclaim their honor at the saloon. Greer, who was probably the least drunk of the bunch, said they should head home, but the liquid courage won out over common sense, and the trio returned to the saloon at about 2:00 a.m.

Upon return to the saloon, the boys were denied entry at the front door. Not to be deterred so easily, Bud and Maloney went to the side of the building, and one of the two chucked a rock through a window, striking one of the patrons inside on the shoulder. Another patron, Jack Wright, grabbed a pistol that had been placed on a piano by a fellow bar patron and let loose with a single shot, undoubtedly an unaimed "shot in the dark." The bullet found its mark on Bud, entering his stomach and piercing his intestines. Bud was quickly picked up by the sobered Greer and Maloney, who carried him to the nearby St. Helena Hotel. Bud lingered for about a day, long enough for the district attorney to hop the train from Napa and take Bud's deathbed statement before Bud succumbed to his wound.

Wright was arrested by Constable McGee and housed in the town's jail; he was taken by train to the main jail in Napa the next afternoon because there were already rumors brewing of people taking justice into their own hands. Unfortunately for Wright, his preliminary hearing would be held back in St. Helena, necessitating his return to town on May 4. During those two weeks, the fervor of local friends of Bud and his family had not abated. The preliminary hearing was brief, and Wright was held to answer on a charge of murder.

Constable McGee was so worried about Wright's safety that he took the jail keys to the safest place he could think of: the house of the local justice of the peace, William Elgin. Inexplicably, McGee and the local town marshal

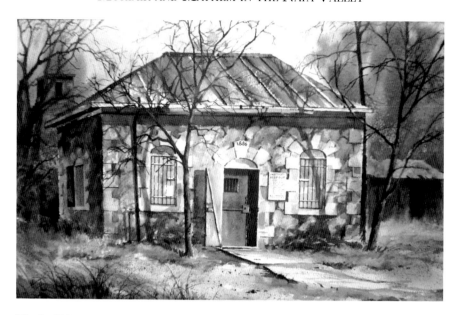

The St. Helena town jail. It was built in 1886 and was home to John Wright in 1888, when he was taken from the jail and lynched. The jail stood until 1960, when it was razed to make way for a private school. *Author's collection.*

then left the jail itself unguarded, instead retiring for the night to the Windsor Hotel downtown to keep the visiting district attorney company. The police night watchman, Henry York, was also worried about being attacked as he made his rounds, so he left his jail keys at home with his wife.

Justice Elgin was awoken just after midnight by the sounds of a mob outside his house. He later reported being called outside to find at least fifteen masked men demanding the jailhouse keys. Elgin, at the time fifty-nine years old, acquiesced and was told to go back into his home. The mob left a guard on him to prevent the alarm being raised and marched to the jail.

Night watchman York discovered the opened jail at about 1:00 a.m. and raised the alarm. Grabbing lanterns, he and Constable McGee conducted a search of the trees with tall branches downtown, expecting to find their missing prisoner. It wasn't until sunrise that Wright's fate was learned, when winery owner Jacob Beringer reported finding Wright hanging from the stone bridge just outside his winery. The lynch mob had used thin, one-quarter-inch clothesline to carry out its sentence, fastening Wright to the iron railing that adorned the top of the stone bridge. The bridge was a mile outside of town, spanning the Napa Creek. Since that time, St. Helena has

expanded north, and the same bridge is driven over every day by hundreds of tourists and locals alike as they travel on Highway 29.

A coroner's inquest was immediately convened to investigate. The only details the coroner's jurors were able to learn came from the elected officials who had bungled their attempts to keep Wright safe. A grand jury was later impaneled and questioned several people about the incident, but no one revealed the identities of the members of the mob. Even a $500 reward offered by the governor's office failed to loosen anyone's lips. The *Napa Register* at the time lamented the lynching, saying, "They [the members of the lynch mob] have committed a heinous crime that is a disgrace to the county."

An interesting postscript to this tragedy came to light in 1939 via an unpublished manuscript written by St. Helena native Rodney McCormick. Rodney was seventeen years old at the time of the lynching, and the morning Wright was found hanging, he noticed a length of clothesline that he usually kept fastened to his dray (wagon) was missing. He asked his father about the missing rope and was told in not so many words to buy a new rope and keep his mouth shut. A few days later, Napa County sheriff George McKenzie rode the train to St. Helena and met with Rodney's father outside the station. Sheriff McKenzie's message was clear: tell the local teens to keep their mouths shut and stop gossiping about the lynching and Rodney's missing rope.

Today, Jack Wright and Bud Vann rest not far from each other in the St. Helena town cemetery, inextricably linked by a night of alcohol and poor decisions and a night of unrestrained brutality on the part of a lynch mob.

CHAPTER 10
THE LAST PUBLIC EXECUTION

Napa County has the distinction, albeit an infamous one, of holding the last public execution in California. How William Roe (alias William Moore) wound up standing on the gallows on that cold winter's day in 1897 and how his accomplice went insane in prison is quite a tale, even in the annals of the Wild West.

The tale of Roe's early life cannot be independently verified but comes to us via a handwritten thirty-five-page confession that Roe scrawled from his jail cell after his crime in Napa. Roe claimed that he was born in Ohio, was orphaned at fourteen and was soon adopted by a family named Crum. According to Roe, his adoptive mother felt that Roe stood to inherit too much of the family's ranch holdings, so she tried unsuccessfully to poison him. She finally settled on a more direct approach, enlisting the aid of Roe's adoptive brother, who sprang into his bedroom with an axe one night. Roe, apparently already wary of his safety after the near-poisoning, drew a gun and shot his kin dead. After the act, the mother was locked up in an insane asylum and Roe was acquitted of the murder.

By his own account, he would go on to be part of a Wild West show and work as a cowhand, a professional gambler and a bronco buster. He even claimed to have committed a series of armed robberies in San Francisco by posing as a police officer, complete with a uniform. Roe claimed to have killed eight people during his life of crime, a number no doubt inflated by Roe's own ego.

In contrast, Roe's soon-to-be accomplice, Carl "Charley" Schmidt, led a more mundane life. A German immigrant, Schmidt spent time as a

A contemporary newspaper sketch of murderer William Roe. *Courtesy of the California Digital Newspaper Collection.*

farmhand in Orem, Utah, before traveling to California to make his fortune. He spent some time working at a farm near Sacramento and then, with his earnings, took the train to the Bay Area. Schmidt spent several days living it up in San Francisco and, when he was down to his last dollar, took the ferry across the bay to Oakland and eventually to Vallejo. At the time, Vallejo was the major jumping-off point for travelers headed from San Francisco onward to Sacramento or north to the Napa Valley. As Schmidt walked along the railroad tracks leading from Vallejo to Napa, he had the misfortune to meet Roe. They made a beeline to several saloons nearby, drinking their way closer to Napa. Finally, the two sat down on the tracks facing a stately mansion south of Napa, the Greenwood Ranch.

John Quincy Greenwood was known around the Napa Valley as "Captain Greenwood," a nod to his many years as a ship's captain before settling down as a rancher in Napa. Captain Greenwood plied the waters along the coast of California and the rivers leading to the ports of Sacramento and Stockton. In 1860, he bought five hundred acres. The Greenwood Ranch

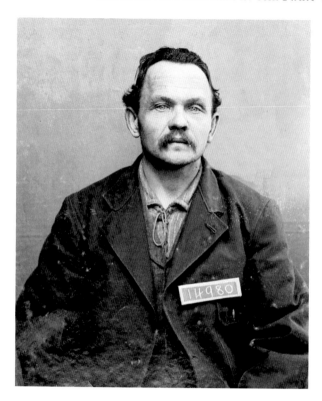

Carl "Charley" Schmidt's 1892 booking photograph from San Quentin State Prison. *Courtesy of the California State Archives.*

encompassed a large swath of land south of Napa in an area presently home to the Napa County Airport and a series of industrial parks. He settled there with his second wife, Lucina Larabee. At the time, the area was known as Suscol and was just south of the Napa Junction stagecoach outpost (now an Italian restaurant at the intersection of Highways 29 and 221).

On the night of February 9, 1891, Captain Greenwood was accosted by two well-dressed men, later identified as Roe and Schmidt, armed with guns as he traversed the distance between a barn and his mansion. When he failed to produce a purse of gold, the robbers took him into the mansion, where he was bound and forced to drink a mixture of chloroform and arsenic that rendered him unconscious. A short time later, Greenwood's wife, Lucina, arrived home. Roe immediately seized her and took her to an upstairs bedroom, where he forced her to drink from the thieves' bottle. Roe and Schmidt ransacked the residence, coming up with four dollars in loose coin. They then piled into Lucina Greenwood's buggy and rode into Napa. According to Roe's confession, he intended to meet up with a former

co-worker named George Knox and planned for the trio to kidnap a bank manager and force him to open the bank's vault. Knox never showed up.

With Roe's plan of robbing the bank foiled, and after a few more beers, Roe and Schmidt returned to the Greenwood Ranch in hopes of finding some hidden cache of gold and probably with the intention of making sure there weren't any witnesses to finger them later. In the interim, Captain Greenwood awoke from the stupor of the drug and threw up, probably saving his life. He was then able to free himself from his bindings. As he mounted the stairs to check on his wife, he ran smack into the thieves, who promptly shot him twice in the face. Greenwood, critically wounded, made a fateful decision that most assuredly saved his life: he feigned death. Roe and Schmidt then rebound Captain Greenwood, and Roe shot Lucina twice in the head, although the later autopsy would show that the poisoning had actually killed Lucina even before Roe pressed the gun to her head. The autopsy also revealed that Lucina had been strangled, with clear finger marks being found around her neck.

Roe and Schmidt then fled on Lucina's horse, heading east through Jameson Canyon, the same route taken by thousands of commuters and tourists each day as they traverse the distance between the Napa Valley and neighboring Solano County. Somewhere west of the town of Cordelia, the horse keeled over from exhaustion and died. Roe gave Schmidt several dollars, and the two men parted ways. Their one day together had wrought dire consequences for everyone involved. Roe wrapped a pistol in his duster jacket and hid it under a railroad trestle; it would be found some months later by a farmer and introduced as evidence during the eventual trial.

By a Herculean effort, the sixty-year-old Captain Greenwood was able to drag himself, still bound, more than one hundred yards from the door of his mansion to the entrance gate of his property. It was there, early the next morning, that Hugh Kelly, a neighbor, found Greenwood near death.

The case was turned over to Sheriff George McKenzie, who was a two-year veteran of the post. Sheriff McKenzie got his first break when he learned that someone matching one of the suspects' descriptions had sold a watch for four dollars to a man at one of the saloons in Napa the day before the crime. He determined that the watch had been repaired at a jewelry store in Napa two years prior. The name listed on the repair invoice was "William Moore." Sheriff McKenzie found that "Moore" had worked as a ranch hand at a nearby ranch and stayed for a time at a hotel in San Francisco.

$4,500 REWARD.

Wanted for Murder and Robbery.

The above reward will be paid for the arrest and conviction of the two men who killed Mrs. Greenwood and robbed the house of J. Q. Greenwood, in Napa County, February 9th, 1891.

DESCRIPTION OF MEN.

The American is about 5 feet 9 inches high; between 30 and 40 years of age; high cheek bones; rather narrow chin; slim build; wrinkles on his neck; dark complexion; looks like a drinking man; dark brown hair; dark mustache; wore gold chain, with broad, flat fob attached; wore a full suit of brown, sack coat, slouch black felt hat, rather high crown, and light-colored overcoat. He is supposed to wear ring on third finger of right hand, with dark stone setting in same. He took a pair of kip boots, well worn, No. 7, split-leather backs and backs rough, as is often the case with split leather; wore red socks.

The Swede (supposed to be Swede or German) is about 5 feet 10 inches high; 25 or 30 years old; square build; round face; small eyes; light complexion; light hair and mustache; wore dark blue suit; white shirt; felt hat, with low crown and round top, brim broad and inclined to be flat; supposed to wear an old, dark gray, shoddy, cheviot ulster overcoat.

GEO. S. McKENZIE, Sheriff,

Napa, February 10th, 1891. Napa, Cal.

The 1891 "wanted" postcard that was sent to agencies throughout the western states by Napa County sheriff George McKenzie. The card provided descriptions of the two as-yet-unidentified suspects: Carl Schmidt and William Roe. *Courtesy of the Napa County Sheriff's Department.*

The signature in the hotel register matched that found on some loose papers that had been abandoned at the Napa Junction, a short distance from the Greenwood Ranch. The papers had the names of several women from San Francisco who had shared their company with "Moore." After questioning these women, Sheriff McKenzie had his first suspect identified: "William Moore" was actually William Roe. The sheriff obtained descriptions of Roe and his cohort from fellow bar patrons who saw them drinking together. "Wanted" flyers went out throughout the western states.

Almost a year later, in January 1892, Schmidt surfaced in Denver, Colorado. After a night of one too many drinks, Schmidt confided to some fellow drunkards that he was wanted in California for a murder. He was picked up by the Denver police, who matched him to the wanted flyer that Sheriff McKenzie had sent. The sheriff obtained an extradition order from the California governor and traveled to Denver to get his man. He questioned Schmidt at the Denver jail, obtaining a full confession. Schmidt fingered Roe as the instigator and murderer; he painted himself to be a hanger-on, forced to be an accomplice at the barrel of Roe's gun.

It would take four more years for justice to catch up with William Roe. In 1896, Roe succumbed to the same truth serum that had done in Schmidt:

alcohol. In a drunken state, Roe brought himself to the attention of the wrong person at a saloon near San Bernardino. This time not only the drink but also the audience would be his undoing. Roe, who was using the alias "George Knight," spoke freely about his crime to a bartender named W.B. Schaug, who just happened to be a former deputy U.S. marshal. Schaug was more than happy to lend an ear to Roe, who dictated a written confession to Schaug during the course of twelve days. Schaug in turn alerted Los Angeles County sheriff John Burr, who took Roe into custody. Roe was found carrying a bottle of poison and a knife. Roe would go on to provide confessions to both Sheriff Burr and Sheriff McKenzie, who traveled south to take custody of Roe.

During Roe's trial, Carl Schmidt was brought back to Napa from San Quentin State Prison in order to testify. It is not clear when Schmidt lost his mind, whether it was before he entered prison or the conditions inside drove him mad. By the time of Roe's trial, four years since his incarceration, Schmidt was confined to an area of the prison known as "crank alley." He was escorted to Napa by the prison physician, Dr. Lawlor. Prior to testifying, he was examined in the judge's chambers to determine his sanity; he claimed that singers were always singing to him and denied ever being in Napa before. Schmidt never took the witness stand and was carted back to the prison, where he eventually died.

Even without Schmidt's testimony, Roe's conviction was a foregone conclusion. He had confessed to several people in the Los Angeles area in addition to the lawmen, and his detailed written confession was convincing. Despite this, his defense team did its best; even Roe himself took the stand. He claimed that the confession he made to Schaug was during a state of delirium. Roe said that when he confessed to Schaug he wanted to die and thought that making such a confession would ensure he would be quickly lynched and allow his new "friend" Schaug to collect a reward. Courtroom observers described Roe as being indifferent during most of the proceedings, even smiling at comments made by jurors during the trial.

On the day of his sentencing, Roe protested that he had not been allowed to call all the witnesses he wished to during the trial and that some of them would provide an alibi that he had been in San Francisco on the day of the murder. Despite this, even Roe admitted that he was "satisfied" with how the judge ran the trial and that, according to the testimony presented in court, a guilty verdict was the right one.

The fact that Roe had been on the run for six years allowed his execution to be carried out in the county where the crime occurred, a practice that had been legislated out of existence by state government since the time of his crime, and Sheriff McKenzie was more than willing to host it. Executions from then until the present day would be carried out behind the walls of San Quentin State Prison.

One of the people who guarded Roe as he awaited his date with the gallows was the sheriff's twenty-four-year-old son, Roderick. In the 1950s, he would recount some details to a local reporter. According to Roderick, the gallows were erected within feet of the jailhouse. As the builders repeatedly tested the trapdoor using sandbags, Roe commented, "If they don't stop working that thing they'll have it all worn out before I get there."

The hanging itself was a very organized affair. The sheriff had a twenty-foot-tall canvas fence erected adjacent to the county jail, on the Coombs Street side of the still-standing courthouse, to shield the gallows. Tiered bleachers were erected to allow everyone in attendance a clear view of the event. The execution was an invitation-only event; four hundred invitations were given to prominent business owners and civic leaders. Women and children were not invited. Photographs that were taken of the crowd that day reveal that everyone turned out in their Sunday finest for the event, and it was a standing room–only affair.

At the rear of the gallows, a small wooden shed was built; inside, three men were stationed, each with a length of rope leading toward the trapdoor. In this manner, none of the executioners would know for sure if his actions caused the door to spring. Sheriff McKenzie lifted his right arm in the air and then lowered it, signaling the release of the trapdoor. The moment is frozen in time, courtesy of a photographer who captured it. Visible in the center of the photograph is a blur, the result of Roe's body in motion as it dropped just before the noose snapped his neck.

The county doctor, Edwin Z. Hennessey, climbed into the cribbing below the trapdoor and pronounced Roe dead. The last photograph taken that day shows the assembled masses crowded around this lower portion of the gallows, with Sheriff McKenzie poised to cut Roe down, a plain pine box positioned on the ground to capture the killer's body. In a fitting bit of irony, Sheriff McKenzie used the same knife that Roe had been captured with, a common butcher knife that Roe had modified and sharpened into a curved blade.

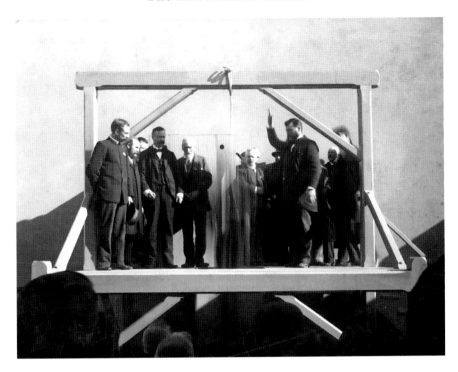

This photograph, taken at William Roe's 1897 execution, captures the moment when William Roe dropped through the trapdoor. *Courtesy of the Napa County Sheriff's Department.*

In later life, Sheriff McKenzie would be elected to the state legislature and author a bill that changed the law so that local officials, such as sheriffs, were able to serve four-year terms instead of two. As an advocate for law enforcement, he also helped pass laws that fixed the fees sheriffs could charge and set basic guidelines to follow for hunting fugitives from justice, as he had done so ably with Roe and Schmidt.

Legend has it that the death of his beloved wife so affected Captain Greenwood that he desired some tangible way to hold on to her memory. Knowing how Lucina loved the freedom that her horse and buggy afforded her, he had the buggy disassembled and rebuilt in an unused room within their house. There he slept, with the buggy at his side, until his death at the ripe old age of eighty-two in 1912. He never again slept in the bedroom where Lucina was brutalized and murdered.

The Greenwood mansion still stands south of Napa, although it was moved about a quarter mile from its original site to make way for a commercial building that now houses the Doctors Company, an insurance company. The

mansion for a time housed the real estate development company tasked by descendants of Captain Greenwood with selling off parcels of the former Greenwood Ranch for development. Several people have reported seeing apparitions in the second-floor west wing of the Doctors Company building; these have been attributed to Lucina Greenwood.

This story has two macabre footnotes. The first involves Roe's body. In Roe's last will and testament, which he dictated to Sheriff McKenzie shortly before his date with the gallows, Roe willed his body to science for dissection, saying, "This has been my wish for years, as I know there is something anatomically wrong in my make-up and I desire to aid science in as much as lays within my power." After Dr. Hennessey witnessed the hanging and pronounced Roe dead, he accompanied the body to an autopsy, which was conducted in San Francisco. A newspaper article published the next year reported, "It is not generally known that for the past six months the bones of William Roe, who was hanged here on Jan. 15 of last year, have been bleaching on top of the Williams stone block. Now let the superstitious ones beware; the goblins'll get them if they don't watch out." It appears Dr. Hennessey used Roe's skeleton as a teaching aide in Napa County schools for many years before it went missing.

If Roe would live on courtesy of Dr. Hennessey, so would the means used to end his life. The gallows used to hang Roe were saved by the county and stored in the attic of the courthouse where he had been tried. Periodically, the gallows would be reassembled and displayed at the county fair. When the Napa Sheriff's Department relocated to its current headquarters in 2004, an allowance was made in the building's design for a small museum. The displays include the gallows, printed photographs of the execution and the noose that broke William Roe's neck and ended California's public executions forever.

CHAPTER 11
BUCKING THE SYSTEM

Many would say that the most famous stagecoach robber of Napa and nearby Lake Counties was condemned at birth, born into a family that would see three of his brothers dead at the hands of others before he turned fifteen. The long-standing arguments of whether genetics or a person's environment predisposes them to becoming a criminal played out in tragic ways in Lawrence "Buck" English's life.

Buck was born into a farming family in November 1853. The family had moved west from Missouri to the Oregon Territory in the 1840s. David, the eldest of Buck's brothers, was lynched along with two cohorts as a highwayman in the Idaho Territory in 1862. Shortly afterward, the English family moved to Northern California, settling in the Green Valley area of Solano County, just east of the Napa Valley. Family tragedy next struck the English family in 1865, when a political argument at a local voting place led to a heated argument between Buck's father and his mother's brother. Pistols and knives were drawn; other family members stepped in to help, resulting in the stabbing death of Buck's brother Perry.

Although Buck and his surviving brothers worked on the family farm by day, they were known to run with a dangerous crowd when not tilling the soil. Buck's brothers Charley and Dan threw in with a gang of ruffians whose favorite activity was spending time in Napa's "Spanish-town." The area was known for its brothels, saloons and dance halls. Charley, Dan and their buddies would generally run roughshod over the area, running up bar tabs and then intimidating the business owners into forgiving them. This

practice caught up with the English brothers in March 1868, when four Mexicans in a dance hall fought back. The result was Dan dead in a pool of his own blood and Charley lying mortally wounded next to him. The four Mexicans who were arrested for shooting the English brothers were eventually released when witnesses reported that they acted in self-defense.

There are two unusual postscripts to this part of the English family crime history. First, it was later reported in the *Napa Register* that on the night of the affray at the dance hall, Charley and Dan English had earlier tried to rob John Lonergan of fifty dollars. Lonergan ran from the English brothers as they shot at him. He only managed to escape by jumping into the Napa River. It's a good thing John did escape, since the grandsons of his yet-to-be-born son would go on to both have lengthy and distinguished careers in Napa County law enforcement: Richard Lonergan would retire as Napa's undersheriff and Dan as a Napa police officer. Second, two of the Mexicans who had initially been arrested and then released for Dan English's death met their untimely ends only a few months later. The Mexicans, who were brothers, went to a saloon in the hamlet of Snelling, in Merced County. After getting drunk, they got into an argument with the establishment's owner, a Dr. Griffith. One of the brothers drew a pistol and was immediately shot and killed by Griffith. The other brother said, "Now that you've shot my brother, I'm going to kill you!" Griffith again was quicker to the draw, killing the second brother. The good doctor was tried and acquitted of murder, claiming self-defense.

The English family uprooted again in 1872 and moved to Lake County, just north of the Napa Valley, perhaps hoping to have a fresh start. By this time, Buck was nineteen and an adroit criminal in his own right. During the next few years, he would be accused of robbing Chinese miners, committing a stagecoach robbery and rustling cattle, with the latter landing him in San Quentin State Prison for two years. Shortly after arriving, he was able to get a new trial on appeal and was exonerated. Buck celebrated by hooking up with several associates to rob travelers on the back roads between Napa and Lake Counties. He couldn't escape justice this time, and in 1878, he returned to San Quentin for a seven-year term.

With time off for good behavior, Buck was released from prison in 1882 and took a job that speaks to the lack of background checks on the part of employers at that time. He worked as a stagecoach driver in Lake County for about a year. He was suspected of robbing one of his fellow coaches a year

later and decided it was time to get out of the area for a while. Buck traveled north, working on ranches in British Columbia, herding cattle and breaking horses. In 1885, he was supposedly wounded while working as a scout for the Canadian army during the Riel Rebellion, a short-lived uprising of aboriginal people. Not one to stay on the right side of the law for too long, Buck was also active in smuggling Canadian whiskey into the United States.

In 1892, Buck was convicted of robbing two Chinese men near Baker City, Oregon. He served two years of a five-year sentence; he was released early after he secured a face-to-face meeting with the governor, pled his case and secured a pardon. After his release, Buck reconnected with a cellmate from the Oregon prison, R.N. Breckenridge, and Buck convinced him that their mutual criminal talents could be best used back in Buck's old stomping grounds of Napa and Lake Counties. The two boarded a steamer and arrived in San Francisco in April 1895. Their date with destiny would come the following month.

May 7, 1895, was a clear, late spring day in the Napa Valley. The Calistoga and Clearlake stage left the city of Calistoga in the afternoon, bound for the

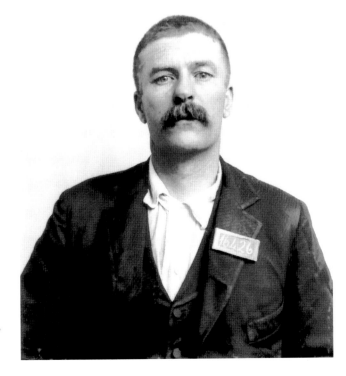

Lawrence "Buck" English's 1895 booking photograph from San Quentin State Prison. *Courtesy of the California State Archives.*

Lake County town of Clearlake. This route was common for San Francisco tourists to take, heading for the resorts along the shores of Clear Lake, as was the case this particular afternoon. It traversed the sides of Mount St. Helena before dropping down into Lake County. In fact, Calistoga embraced the fact that it was a jumping-off point for Lake County, erecting a sign across the main road stating that it was the "Gateway to Lake County."

Buck and Breckenridge waited in the brush along the road, armed with a shotgun and masked to hide their identities. They wore dark gray duster-style jackets and black slouch hats. The bandits sprang from their hiding spot as the stage approached, leveling the shotgun at the driver to stop him in his tracks. This particular stage did not carry an armed guard riding "shotgun" with the driver. Buck quickly found that the express box was empty, so he and Breckenridge robbed the passengers of their watches and cash. The reported take was about $1,200. One of the passengers would later recall that the stage driver, A.L. Palmer, was so calm that he continued to chew tobacco and spit it at regular intervals during the entire robbery. Palmer later explained that he had been robbed on two previous occasions at exactly the same spot.

Lawmen from both Lake and Napa Counties began searching for the bandits. Lake County sheriff Pardee and Napa constable Allen started out in the town of St. Helena, checking the mining camps near Oat Hill. At the same time, Napa sheriff McKenzie traveled to the Solano County town of Winters, just east of the Napa Valley, and began backtracking toward Monticello. Two days later, the bandits turned up in the Berryessa Valley near the town of Monticello, in the far eastern portion of Napa County. Monticello was abandoned in the 1950s and is now at the bottom of the man-made Lake Berryessa.

Buck and Breckenridge ate breakfast at a farmer's house and then walked to a nearby stage depot, paid the fee of $1.50 apiece and hopped on the coach that ran regularly from Monticello to Napa. Buck sat next to the driver, Johnny Gardner, and the stage began its trek toward Napa. Gardner recognized Buck and Breckenridge as matching the descriptions of the robbers provided by the stagecoach line. Before he left, Gardner had a chance to place a phone call ahead to Napa to alert the authorities of Buck and Breckenridge's movements. The sheriff was out of town, so Undersheriff Brownlee took charge; he quickly assembled an impromptu posse composed of Jack True, Johnny Williams and District Attorney Theodore Bell. They

piled into a buggy and lit northeast out of town, toward Monticello, hoping to find a good spot for an ambush to wait for the stage.

At about 10:30 a.m., the stage reached the crest of the Berryessa grade. The buggy with the posse aboard approached from the west; the posse's hopes of setting an ambush had been dashed by the speed of the stage. As the stage and buggy got to within eight feet of each other, Buck and Williams both raised their shotguns, and shots rang out. Bell hit Buck in the hip as he ordered Gardner to speed on; Gardner then received a spattering of buckshot from the posse. The shot from Buck's gun peppered the legs of Undersheriff Brownlee and Williams, although the bulk of it hit the stock of Brownlee's shotgun. It was a good thing, too, since Brownlee was holding the shotgun between his legs at the time. Thus, the gun literally saved his manhood.

Buck drew a pistol and tried to command Gardner again; however, Buck soon passed out, and Gardner was able to stop the stage about five hundred yards past the shooting site. During the confusion, Breckenridge leapt from the stage and tried to make a break. Jack True took aim and shot Breckenridge in the leg. Breckenridge immediately held up his hands,

The butt of the shotgun that probably saved the life of Napa County undersheriff Brownlee; the damage on the gun denotes where Buck English's shot struck. *Courtesy of the Napa County Sheriff's Department.*

shouting, "Don't shoot, don't shoot!" Although Breckenridge didn't fire at the posse, a pistol was found in his jacket pocket.

The first question Buck asked Undersheriff Brownlee after he was captured was, "How many of you fellows did I kill?" He was rather disappointed to learn that none of the lawmen's injuries was life threatening. In his pocket were three of the four watches lifted from the stagecoach passengers from the earlier robbery, as well as a large portion of the coin. District Attorney Bell saw Buck throw the fourth watch away during the shootout, but it was later recovered by a rancher and turned over to the sheriff. Buck got to finish the stage ride he had started in the morning, now as a mortally wounded robber in the custody of the undersheriff.

Many people didn't think Buck would survive his wounds, but he was from strong stock. He had taken buckshot in his arm, thigh and side, breaking two ribs. Newspaper reports indicated that in addition to the buckshot plucked from his body, the doctor also removed two rifle slugs that had been lodged near Buck's spine, souvenirs of his earlier exploits.

Breckenridge at first gave a false name; however, lawmen backtracking Buck English's movements contacted the chief of police in Portland, Oregon. They learned that Buck had left on the steamer for San Francisco with Breckenridge. The Portland chief reported that Breckenridge was a reform school dropout who had served time in prison for burglary and that he had been a member of "Coxey's Army," a short-lived protest movement in 1894 made up of unemployed workers angry with the government. Breckenridge was tried separately from Buck while Buck was still recuperating from his wounds; Breckenridge received a twenty-five-year sentence.

A day before Buck's preliminary hearing in July, he played one last card: attempting to escape from jail. Although still recuperating from his wounds, he enlisted the aid of two fellow prisoners, Pat Read and Ernest Easton, who were serving three-month terms for disturbing the peace. At the time, the jail was connected to the main courthouse by a two-story hallway; the top story had a few iron barred windows and iron doors at each end and was used to store prisoners' personal effects. The sheriff had made the unwise decision not to lock the prisoners in their individual cells at night. Fortunately, the sheriff got word of the planned escape and was able to find an already damaged padlock on the iron door at the jail's end of the hallway. The would-be escapees had been using a makeshift saw to cut through the padlock, using some wax to conceal the cut marks.

Bucking the System

Sheriff McKenzie set up surveillance on the hallway, peering through a small grate on the door at the courthouse end of the hallway, and made sure other lawmen were stationed just outside the jail in case the escape was accomplished. When the prisoners completed their work on the padlock, they quietly swung open the door, made a beeline for one of the windows in the hallway and began sawing away on the iron bars. The sheriff had set up an ingenious way to determine which prisoners were involved. He took a large syringe and filled it with red ink. When the prisoners walked over to the door at the courthouse end of the hallway to look through the grate, they were surprised to receive facefulls of ink. The now-marked men quickly ran back to their jail cells, their plans for freedom foiled.

Two days after the escape attempt, Buck strode into court and pled guilty to the stagecoach robbery. Judge Ham sentenced him to the maximum penalty: life. The only concession made by the judge was honoring Buck's wish to be housed at San Quentin State Prison instead of Folsom. The *Napa Daily Journal* reported that a sizable crowd went to the train station to see Buck off as Sheriff McKenzie escorted him to prison.

By all accounts, Buck was a model prisoner. He appears to have genuinely turned over a new leaf, even counseling younger inmates not to choose the life of crime as he had. After serving seventeen years of his life sentence,

The Napa County Courthouse, circa 1874. The sight of the Buck English and R.N. Breckenridge trials, the courthouse still stands today (minus the cupola) and is an active courthouse. *Courtesy of the Napa County Historical Society.*

Buck was paroled in February 1912. He went to work in the stables of Luke Fay, a prominent San Franciscan who owned a soap factory in the city. Fay had advocated for Buck's release, promising the parole board that he would provide Buck with gainful employment. Buck English died three years later, in 1915, just shy of his sixtieth birthday.

Buck English remains the Napa Valley's most famous old West outlaw. The shotgun that saved Undersheriff Brownlee is on display at the Napa Sheriff's Department Museum.

CHAPTER 12
A CUP OF JOE

It all started with a cup of coffee, the nectar of the gods for many a weary worker early in the morning, both today and 114 years ago, in 1898. It was a necessity for men like William Clark, a signalman for the Southern Pacific Railroad in St. Helena. His day started before daylight and involved many hours of demanding, physical work. One morning when William took a sip of his coffee, he noticed a bitter taste; soon afterward, he became violently nauseous. A local druggist detected traces of strychnine in the coffee. A second similar incident followed within the week. Suspicion within the Clark household, along with rumors around town, settled on William's brother, George, who was living at Clark's residence. For reasons that remain unclear, the local authorities never investigated the two attempted poisonings. The only penalty George suffered was being thrown out of the Clark household; he moved into a cabin on the property of Dr. Osborne, the local healer.

The troubles between William and George had been brewing for many years, long before the pot of poisoned coffee. The close relationships among William, George and William's wife, Lovina, went back many years to when the trio lived in Illinois. Lovina, who was eight years older than William, had known him since his birth and was in fact his high school teacher. She lived with the Clark family in Illinois before marrying William.

After the family moved to California, George lived with them for about a year; however, the strained family relationships led the patriarch of the Clark family to have George return to the family homestead in Illinois. Against

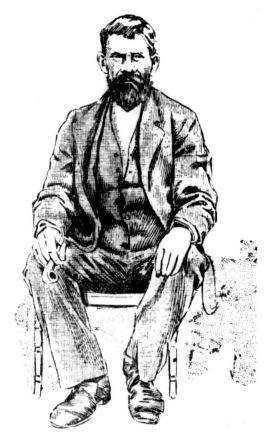

A contemporary newspaper sketch of murder victim William Clark. *Courtesy of the California Digital Newspaper Collection.*

his father's wishes, George returned to St. Helena and resumed living with William and his family. It was then that the coffee started to taste bad.

George moved out of the Clark residence, and all was quiet until the morning of January 21, 1898. Lovina was the first to notice a problem; she heard struggling and moaning coming from the kitchen of their small house. It was William's normal routine to wake early, pack his lunch and head out to his job at the Southern Pacific Railroad terminal. When she investigated, she found William lying on the floor. She rolled him over and found him mortally wounded, a single bullet lodged in his head. A .32-caliber revolver was lying next to the body.

Early forensics helped build a strong case against George. The key evidence was the freshly muddied shoes found when Constable Logan Spurr found George. The constable and City Marshal Johnson were able to match the shoes to tracks found leading from William's house straight to George's cabin. In addition, when the officers searched George's cabin, they found a box of pistol shells, the same caliber as the gun that was left next to William's body. The box was missing only five shells, the exact number loaded in the discarded pistol. The cabin also yielded a "suicide note" supposedly written by William. In it, the writer disclosed that a packet of strychnine would be found secreted in the back of a clock in William's residence. The note also conveniently had

a line proclaiming, "George is innocent." Apparently, George had intended to "find" the note after his brother had died from the strychnine-laced coffee and planted the strychnine in William's residence to bolster the suicide story.

George's professions of innocence lasted all of two days until a reporter from a San Francisco newspaper convinced him to tell the truth. After the coroner's inquest, Sheriff McKenzie sat down with George in his jail cell. In a move that sounded like a precursor to a Miranda warning, the sheriff told George, "Mr. Clark, I desire to inform you, if you are not aware of it, that you need not speak unless you wish to. Talk if you desire, but don't if you wish not."

Sentiment around St. Helena and in Bay Area newspapers was less than flattering about George's character. He was described as a religious fanatic, apparently because he had changed denominations three times. George was called a moral imbecile, weak faced, feeble and meek. These feelings weren't helped when the sordid details of George and Lovina's relationship began bubbling to the surface during the coroner's inquest. Apparently, George was the father of at least one of Lovina's seven children. They had an intimate relationship from the time she married William until about seven years before the murder, when she found God.

If all the sordid details of the crime weren't enough, George also confessed that he and Lovina had burned his cousin's house in Pope Valley. At the time the entire Clark family, including George, was living with the cousin. In a bizarre scheme aimed at forcing William to move the family to St. Helena, George and Lovina waited until the children were at school and William was at work before setting a match to the place. The arson had the desired effect, as the Clarks moved into town afterward.

As the preliminary hearing approached, George was rightly concerned about his safety, since it was only ten years earlier that Jack Wright had been lynched in St. Helena. As was the practice at the time, preliminary hearings were held in the township where the crime occurred and were presided over by the locally elected justice of the peace. Much to George's chagrin, he was taken from the county jail in Napa, loaded on a coach by Sheriff McKenzie and transported back to St. Helena. Despite George's fears, his short stay in St. Helena was uneventful, most probably due to the diligence of Sheriff McKenzie and the extra guards he stationed at the jail.

George's trial took place in March. Some of the most damning evidence came from the now-widowed Lovina, who said that on several occasions George asked her if she would marry him if William were dead.

George Clark's 1898
booking photographs
from San Quentin
State Prison. The top
photograph depicts
Clark as he looked
when he walked into
the prison; the bottom
photograph shows him
after being in-processed.
*Courtesy of the California
State Archives.*

The entire defense case took less than a half hour. It consisted of three character witnesses and a young woman who gave George a weak alibi. Accounts of reporters all credit District Attorney Theodore Bell with presenting a compelling closing argument. In one reporter's words, Bell "tore to shreds Mr. Hogan's [the defense attorney] oratorical fabric, and he dashed aside his theories one by one."

In the end, all George's defense team could do was try to shift blame away from George and onto the third leg of the lovers' triangle, William's widow, Lovina. Failing this theory, attorneys attempted to show that William could have shot himself and emphasized that the lack of mud on William's porch poked holes in the prosecution's footprint evidence.

The jury took only an hour to decide George's fate, guilty of first-degree murder, and recommend the death penalty. Upon hearing the verdict, George hung his head and broke down in tears. The sheriff reported that after the trial, George restlessly paced back and forth in his cell, sobbing.

George's date with the hangman's noose was on October 21, 1898, in the yard at San Quentin State Prison. The relatively short time between conviction and execution is in stark contrast to the state of affairs now in California, where the average death row inmate has been there over twenty years.

As George mounted the steps leading up the scaffolding, onlookers heard him repeating, "Bless the Lord!" over and over again. As the hangman began to pull the black hood over his head, George asked to make a final statement; however, once allowed to do so, he was unable to speak, overcome by emotion. A reporter who was present noted that it took only nine minutes for George's body to stop twitching after the trapdoor had been sprung.

CHAPTER 13
THE BELLE OF CHILES VALLEY

The year 1898 marked several milestones of tragedy for the Napa Valley. Early in the year, George Clark killed his own brother, William, in a bizarre love triangle and plot to take over William's family as his own. This tragic story is detailed in the previous chapter. Just as Clark's case was going to trial, a sensational murder-suicide would rock the Napa Valley. The violent, senseless incident would highlight how unrequited love could go horribly wrong.

The Sasselli family lived at the west entrance to Chiles Valley, which is located along the east hills of Napa County, about thirteen miles east of St. Helena. The valley was named after Joseph Ballinger Chiles, an early pioneer of the county who received a Mexican land grant in 1841 known as Rancho Catacula. In 1845, Chiles erected the first flour mill built by an American in Northern California. The patriarch of the Swiss-Italian Sasselli family was Joseph Sasselli; he and his wife had seven children. The eldest daughter, Victorina, was just shy of eighteen in 1898. Contemporary newspapers described Victorina as very attractive and accomplished; she was dubbed "the Belle of Chiles Valley" by the *San Francisco Call*. Victorina could speak three languages fluently and was an accomplished pianist.

Julius Bhend was a Swiss immigrant who had come to America seven years earlier. He arrived in the Napa Valley in 1897, when he was twenty-five, and took a job as a farmhand for Henry Sievers a short distance from the Sasselli homestead. Julius took a fancy to Victorina and tried courting her; however, her parents disapproved. There is some indication that the parents were

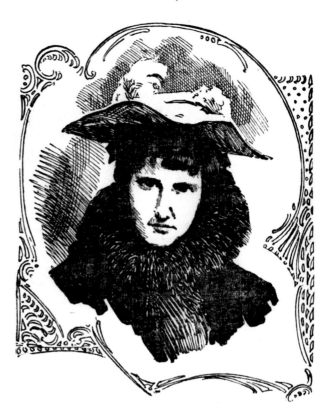

Victorina Sasselli, dubbed the "Belle of Chiles Valley" by contemporary newspapers. *Courtesy of the California Digital Newspaper Collection.*

not happy with the age difference of the lovebirds or with Julius's station in life. Ignoring these concerns, Julius proposed to Victorina. She turned Julius down, explaining that she didn't feel old enough either.

On March 18, 1898, Julius called at the Sasselli home, purportedly with a plan to take Victorina to St. Helena to get her photograph taken. Mrs. Sasselli explained to Julius that Victorina and her father had left earlier that day for St. Helena so Victorina could get fitted for a new dress. Undeterred, Julius started off for town to find them.

As he reached a spot on the road known as horseshoe bend, Julius intercepted Victorina and her father, who were by now on their way home after their day of shopping. Julius explained his photography plan; however, Joseph Sasselli refused to let Victorina accompany Julius back to town since it was already late in the day. Julius convinced Joseph to let Victorina ride in his buggy on the pretense of driving her home. Once the exchange was made, Julius whipped his horse to a gallop and pulled away from Joseph's buggy.

Joseph only had to ride about a mile to find the body of Julius. He lay dead on the side of the road, a hole in his head and a Smith & Wesson pistol in his hand. Victorina and Julius's buggy were nowhere to be found. Now frantic, Joseph rode on.

When Joseph reached his home, his worst fears were realized. The horse and buggy was stopped in front. Miraculously, the pilotless horse had maneuvered the winding, narrow canyon road without a driver. The body of Victorina lay in tragic repose. Julius had shot her, causing her to slump in the buggy, her dress getting caught in the foot step of the buggy, her long, dark hair caught and wrapped around one of the buggy's wheel spindles as the buggy had made its way home. A neighbor, Caterina Nichelini, had stopped the horse and buggy as it passed her property and was already trying in vain to staunch the flow of blood from the two .38-caliber bullet holes in Victorina's head; she died a few minutes later. The Nichelini family still runs a winery at their property near the Sasselli homestead; the Nichelini Winery is the oldest continuously run family winery in the Napa Valley.

Friends and relatives of Victorina struggled to understand why Julius would take the life of his one true love. The motive behind Julius's senseless actions would not remain a mystery for long; a note addressed to Victorina's mother was found in Julius's pocket. It read, "Madam Sasselli, I am writing you for the purpose of demanding your pardon for the act that I have intention of doing. I would rather die with her than be separated from her. I love her too much to see her in the arms of another. Yours devotedly, Julius Sasselli."

Julius and Victorina are both buried at the historic St. Helena cemetery within a few paces of each other. In a strange way, Julius got what he wanted: to never be separated from his beloved Victorina.

CHAPTER 14
A SOLID COMFORT HOME RESORT MURDER?

In 1898, Addison Allen was sixty-five years old. The Kentucky native and his wife, Anna, were the proprietors of the successful Solid Comfort Home Resort. By this time, the Allen family had already dealt with one unexpected death: the loss of their son ten years earlier. He was a passenger on the SS *City of Chester* when it collided with another steamship in the San Francisco Bay.

The Solid Comfort Home Resort was located on the slopes of Mount Veeder, about nine miles northwest of Napa. Perched about two thousand feet above the valley floor, the resort offered exceptional vista views. Visitors from the Bay Area made the trek to Napa via ferryboat across the bay and then either train or stagecoach to Napa. They then spent $1.50 to ride a stagecoach that climbed the bumpy, ruddy road up the mountain to the resort.

On a Thursday afternoon in September, Addison was riding back to the resort from the city of Napa. He was riding on what is now known as Browns Valley Road, west of the city near the Buhman Ranch, when he was thrown from his buggy. The driverless buggy was noticed by ranch hands at the Buhman place. They came to Addison's rescue and transported him the rest of the way to his resort, where he regained consciousness briefly before succumbing to his injuries. It would be this brief period of apparent lucidity that would haunt a man and his community.

Two days later, when the coroner came calling at the resort, witnesses reported that Allison had made a deathbed accusation of murder. A coroner's inquest was hastily called and the witnesses brought in to recount what Addison had said. The attending physician who had treated Addison, Dr. Pond, testified that Addison initially didn't recall what had happened to

A turn-of-the century postcard for the Solid Comfort Home Resort. *Author's collection.*

him; however, later in the day on Friday, Addison claimed that he had been assaulted by a former African American worker of his named John Clemens. He said Clemens ambushed him by coming out from behind some brush and striking him on the head and neck with some sort of pipe or club. The autopsy determined that Addison not only had a contusion on the top of his head but also one on the back of his neck. Dr. Pond opined that the injury to Addison's neck was caused by some sort of blunt object and not from a fall from a buggy, thus bolstering Addison's claim.

Clemens was initially arrested by Napa police officer George Secord; however, he was quickly released when he produced an alibi showing he was in the city of Napa at the time of the alleged attack. His alibi came in the form of two men beyond reproach: Justice of the Peace William Bradford and Officer Secord himself, both of whom saw Clemens in town well after Addison left, making it impossible for Clemens to have overtaken and set up the ambush that Addison described.

Further investigation revealed that Addison had been drinking heavily while in Napa. He had seen Clemens not on Browns Valley Road but in Napa while going into a saloon. A witness reported overhearing Allen invite Clemens to drink with him, and Clemens declined the offer. It was soon after this that Addison hopped into his buggy and rode off.

A Solid Comfort Home Resort Murder?

Clemens was so adamant about his innocence that after his release from jail, he walked into the district attorney's office and demanded to be arrested so he could be vindicated in a court of law. His offer was declined, and the matter was dropped. No one was ever arrested for the alleged attack, and as of two years later, during the 1900 census, Clemens was no longer living in Napa.

Around the time of Addison's death, the Solid Comfort Home Resort advertised among a litany of other health resorts in both the San Francisco and Sacramento newspapers. Most of these resorts were located within the Napa Valley. The resort boasted "mountain spring water, fine scenery, healthiest climate, and positive cure for asthma." All these benefits could be had for the sum of eight dollars a night. The resort was seasonal, open from July through January each year. It joined the ranks of other resorts that followed in the footprints of Sam Brannan's Calistoga Resort such as the Aetna Springs Resort and the Napa Soda Springs Resort.

Only after his death did the extent of Addison's drinking problem become known. He and Anna's beloved resort was heavily mortgaged. Addison's love of liquor overshadowed his love of the resort he and Anna had built, and she lost it to the bank in foreclosure. Within two years, Anna was listed in census records as being a boarder in someone else's home in Napa. Anna's health began to fail, and by 1901, she would wind up in the City & County Hospital of San Francisco, living off the charity of others. She spent the last three weeks of her life in the private residence of Annie Swartz, a stranger who took pity on Anna and volunteered to care for her after her release from the hospital.

On July 21, 1901, the *San Francisco Call* reported that Anna ended her own life by taking a fatal dose of strychnine. Anna left a note that read, in part: "I do not fear death. I have always tried to live right through life. My suffering is too great which I cannot endure. I chose death by my own hand with strychnine which I had over three years in my possession. Homeless, helpless, and destitute, I could not even get any medicine to relieve pain without the money. I think it better to be at rest."

The resort the Allens founded changed its name to the Lokoya Lodge in 1925. The lodge became known for its log cabins and wood-hewn gathering hall and dining room. It continued to serve weary Bay Area citizens in need of respite from their everyday lives well into the 1950s, when a large part of the resort burned to the ground. Today, there are ongoing negotiations between the current owner of the property and Napa County to rebuild the resort and reopen it to a new wave of visitors seeking an escape from their daily lives.

CHAPTER 15
A MINE MURDER

The Oat Hill Mine was the largest of a group of mines that dotted the hills east of Calistoga. It operated off and on for more than fifty years, becoming the largest producer of cinnabar in the world. Cinnabar, when processed, produces quicksilver, better known as mercury. Cinnabar had been discovered in the hills above the Napa Valley during the 1860s, when a farmer noticed it on the ground after a brush fire swept through the area. The Oat Hill Mine even created the town of Oat Hill for a time; it never got much bigger than 350 residents, but it did have its own Wells Fargo office, a church, a post office and a general store. The mine employed a mixture of Chinese and European immigrant labor eager for any type of work, even the backbreaking, dangerous labor deep inside the mines, braving the toxic fumes common with mining cinnabar.

Cinnabar was highly sought after throughout the late 1800s and early 1900s by the still-active gold miners of the Sierra Nevada, who used it in the reduction process to help filter the gold flakes from sediment and ore. In the early 1890s, a serviceable road was constructed to the Oat Hill Mine, making the extraction and transport of cinnabar much easier.

The headlines of the *San Francisco Call* on May 10, 1902, told the tale: "Brutal Murder Near Calistoga: Three Oat Hill Mine Employees Take Life of Comrade." The news first came from the mine's foreman, John Walters, who also happened to be a Napa County deputy sheriff. He raised the alarm by traveling to Calistoga first and then boarded the southbound train en route to Napa. Walters had two purposes: he wanted to notify Sheriff

A Mine Murder

The road leading to the Oat Hill quicksilver mine. *Author's collection.*

Dunlap in Napa, and he hoped that the murderer who fled might hop on the train somewhere south of Calistoga.

The crime itself involved a trio of Italian immigrant miners: Antonio Tavano, Amadio Franchinetti and Emilio Pefferini. The group confronted a fellow worker, a German immigrant named Charles Englehardt, in the mine's bunkhouse. A knock-down, drag-out fight ensued, during which Tavano pulled a knife and tried to stab Englehardt in the back. Pefferini was able to stop him and wrest the knife away from Tavano, hiding it under the mattress of a bunk. The fight then spilled out of the building to the ground in front. During the confusion, Tavano grabbed a miner's candlestick and wielded it as a weapon, finishing what he had intended to do inside the bunkhouse by stabbing Englehardt in the throat and chest.

Before the mid-1800s, miners secured candles to their caps or to the rocky walls of the mine using clumps of clay. Miners in the Comstock silver mines in Nevada invented the miner's candlestick sometime in the 1860s by bending the end of a spike to hold a candle. The spike then could be jabbed into wooden support beams or crevices in the walls of the mine. In short order, the device was refined to include a curved hook near the candleholder, enabling the miner to attach a candle to his cap and creating an early version of a headlamp.

Deputy Walters would report that all the workers involved had recently been hired at the mine. Tavano had come from San Francisco only two months prior. It was later learned that Tavano had immigrated to the United States in 1894, landing in New York as many thousands of others had. He took jobs at several different coal mines in Pennsylvania before hopping on a train to California in March 1902.

An example of a "miner's candlestick." These devices, modified iron stakes, were originally invented in the silver mines of the Comstock Lode. *Author's collection.*

The sheriff immediately formed a posse and began searching the hills near the mine; he also offered a $100 reward, hoping to enlist the aid of the homesteaders and farmers who lived in the area. A wanted flyer described Tavano as follows:

> *Tavano is an Italian, 28 years old, 5 feet 4 inches tall, weighs 140 pounds; heavy, stout shoulders; large, dark eyes, showing considerable white; black hair, black mustache, not very heavy; is wearing a black coat, gray vest, gray pants, old white soft hat, red colored shoes; may have on a pair of coveralls over trousers, as they are missing; negligee shirt, stiff collar and bow necktie. Speaks fair English.*

Tavano's fellow brawlers, Franchinetti and Pefferini, were taken into custody at the mine and then transported to the nearest jail in Calistoga. Franchinetti refused to discuss the incident; Pefferini, however, made a statement claiming that the incident was payback, orchestrated by Tavano because Englehardt and Tavano had argued earlier in the week. Testimony from other miners who witnessed the mêlée reported that the trio of Italians came into the bunkhouse late in the evening, drunk and rowdy. Englehardt got mad due to the loudness of the drunks and tried to eject the loudest, Franchinetti, from the bunkhouse. Tavano was more than willing to defend his friend, as he already held a grudge against Englehardt, and repeatedly said, "I'll fix him, I'll fix him." After the stabbing, the trio allegedly went back into the bunkhouse to sleep it off, not realizing that the wound to

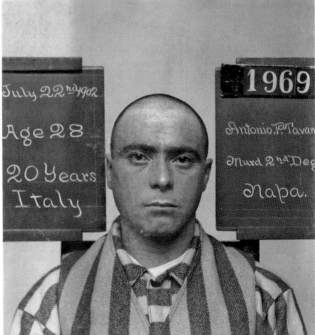

Antonio Tavano in his 1902 booking photographs from San Quentin State Prison. *Courtesy of the California State Archives.*

Englehardt was serious. Later in the night, Pefferini went back outside, found Englehardt's body and alerted his buddies. Tavano panicked, grabbed a pistol from the bunkhouse and disappeared into the hills.

Sheriff David Dunlap and Constable Charles Allen were hot on Tavano's trail. They started by checking several nearby mining camps and then headed over the hills into Lake County to check on a reported sighting in the town of Middletown. That sighting turned out to be false, so the lawmen next traveled west of the mines to Pine Flat, just over the county line in Sonoma County. As they were riding on a parallel trail, they noticed a man with a white hat trying to hide behind a tree on the other trail. The officers quickly raced ahead, concealed their horses and waited in ambush for their prey. When the man came within twenty-five yards of their position, Sheriff Dunlap sprang up and ordered the man to stop. The man reportedly shouted, "No shoota, no shoota" and gave himself up. He admitted being Tavano and said he was from the Oat Hill Mine. He had been on the run for three days.

Tavano told the officers that he had been sleeping in the wilderness and had only eaten once since the night of the murder, when he made his way to Calistoga and received some bread from a fellow Italian immigrant. He had seventy-four dollars in gold coins in his pocket, apparently his earnings thus far from the mine. He was taken briefly to the jail in Calistoga and then on to the county jail in Napa.

Tavano was interviewed and claimed self-defense. He explained that a few weeks before, Englehardt had been upset by someone in the bunkhouse snoring too loudly. When Tavano tried to calm Englehardt down, Englehardt allegedly threatened to "fix" Tavano. He said he had complained to the mine foreman about Englehardt and the foreman had agreed to calm Englehardt down. Tavano was not clear on the exact details of the murder, claiming a hazy memory due to the liquor he drank that night, although he claimed he wasn't intoxicated. He did recall that Englehardt was drunk as well. Tavano said neither of his friends was to blame. He claimed that Franchinetti tried to act as a peacemaker and Pefferini stood by, holding a lantern.

One of the witnessing miners signed a complaint against Franchinetti and Pefferini as accessories to murder. This put the district attorney, Theodore Bell, in an awkward position: he told Justice of the Peace Caldwell that he didn't think there was enough evidence to charge either man but he was required to allow the witnesses to testify. At the end of the preliminary hearing, Justice Caldwell of St. Helena held both Franchinetti and Pefferini

to answer for being accessories to murder. After the ruling, Bell addressed the court: "I consider the holding of these two men a travesty of justice. I believe that the re-arresting of these men is simply a piece of dirty politics in this County aimed at the Sheriff's office and the District Attorney's office." Bell went on to say that if the superior court in Napa didn't dismiss the case he wouldn't prosecute, forcing the state attorney general's office to take over. Bell's opinion would be affirmed a few weeks later when the case came before superior court judge Ham in Napa. Ham ordered Franchinetti and Pefferini released due to lack of sufficient evidence.

During Tavano's trial in July, he wept as he described fearing for his life as Englehardt struggled with Franchinetti, thinking that Englehardt would break away from Franchinetti and attack him. He said he stabbed Englehardt in self-defense. The jury deliberated about three hours before returning a verdict: guilty of second-degree murder. Barely two months after the crime, Tavano was sentenced to serve twenty years in prison.

Tavano would wind up making a powerful friend at San Quentin, a fellow inmate named Abraham Ruef. Ruef was an attorney and politician who handpicked and orchestrated the election of San Francisco mayor Eugene Schmitz in 1902. Shortly after the great earthquake of 1906, a scandal was revealed in which Ruef had bribed several city supervisors to steer public works contracts to Ruef's friends. Ruef was sentenced to fourteen years in prison, and after several appeals, he entered San Quentin in 1911. The Ruef scandal would come to be known as the most important corruption case in San Francisco history.

Ruef convinced an attorney friend, Bert Schlesinger, to vouch for Tavano when a parole opportunity came in 1913. When Tavano was granted parole, Schlesinger wound up hiring Tavano to tend the gardens at Schlesinger's "country place" in the town of Los Gatos. Schlesinger also went to bat for Tavano in 1914, writing a letter to then-governor Hiram Johnson asking for a pardon. He used a similar argument as Tavano had used at trial: that Tavano had been bullied by Englehardt in the past and that he acted in self-defense when he stabbed Englehardt. Tavano even convinced Theodore Bell, the Napa County district attorney who had tried his case, to write a letter recommending the pardon. The governor was not moved, and Tavano continued on parole until 1915.

The Oat Hill Mine produced cinnabar off and on into the 1980s, when it was shut down due to safety concerns. Today, the road constructed to the mine in the 1890s is a popular hiking trail within the Robert Louis Stevenson State Park.

CHAPTER 16
A MAN WHO WENT SOUR

In 1935, Union Station was an outpost on the northern edge of Napa. It was a freight depot for the railroad that snaked its way up the valley, a vital spot where the fruits of the valley—such as wines, grapes and prunes—were loaded onto trains for the trip south to Vallejo and on to the Bay Area. The site is currently an underpass at Trancas Street and Highway 29. Besides the railroad terminal, a small grocery store was situated at Union Station. The store was owned and run by Baptista "Robert" Acquistapace. He was a native of Italy, forty years old in 1935. He had served for his homeland during World War I, suffering injuries during a poison gas attack. Acquistapace immigrated to the United States shortly after the Great War, settling briefly in Santa Barbara County with an uncle. He later moved to the Napa Valley to live with another uncle who owned the general store. The uncle died in 1929, willing the store to Acquistapace. By all accounts, Acquistapace was a loner who kept to himself. He lived in the back room of the store.

Early on the morning of October 21, a neighbor named Archie Emery came to the store for a beer, as was his custom. Emery found Acquistapace lying gravely wounded in his back bedroom, delirious and suffering from a serious head wound, the victim of a vicious beating. Emery ran to the closest telephone at a neighbor's house and called for help. Napa County undersheriff William Gaffney was put in charge of the investigation. The motive for the beating was quickly deduced based on the still-opened and empty cash register; a few pieces of loose change were all that remained, strewn on the floor.

A Man Who Went Sour

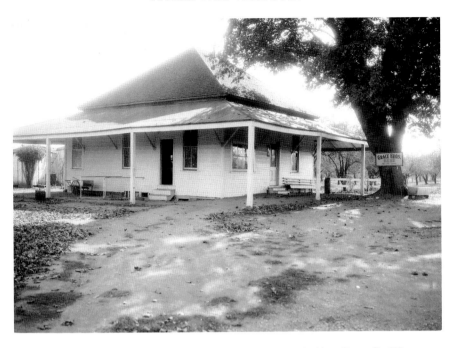

The Union Station Market as it appeared in 1935. *Courtesy of the Napa County Sheriff's Department.*

Acquistapace was rushed to Napa's Victory Memorial Hospital. He fought valiantly for six days in the hospital, even as Napa County lawmen fanned out to hunt for his attackers. He finally succumbed to his injuries on October 26. Napa's sheriff quickly realized the need for outside help, especially since this was the valley's first murder in seventeen years. Two agents from California's Bureau of Criminal Identification in Sacramento were called in to process the crime scene. They documented the evidence at the store, which told the story of the crime: bloodstains and turned-over merchandise as Acquistapace fought for his life. After an initial fight in the store, Acquistapace was dragged to his bedroom and left for dead. Bloody, smeared fingerprints were found, as well as some loose hairs. Blood was also found on the front porch of the store, left as the killer or killers fled. The total take: twelve dollars and a cheap bottle of wine.

Suspicion immediately fell on two suspects: Bernard Bell and Frank Pedrini, ex-cons who had been staying since August in a nearby shack near Pedrini's mother's house. They had met while serving terms at San Quentin State Prison, Bell for robbery and Pedrini for burglary. Bell was from the

The interior of the Union Station Market. Blood from the violent murder of Baptista "Robert" Acquistapace is visible on the floor. *Courtesy of the Napa County Sheriff's Department.*

Los Angeles area; Pedrini was a Northern California native who started his criminal career in 1928 with a conviction for fishing out of season in Siskiyou County. He graduated to armed robbery in San Francisco. Bell and Pedrini were questioned early in the investigation but claimed no involvement. The undersheriff did discover two damning pieces of evidence. On his deathbed, Acquistapace had murmured the name "Frank" several times and reported his attackers were a tall and short man, which matched descriptions of Bell and Pedrini.

Four days after the attack, Undersheriff Gaffney and Deputy Karl Graham tracked Bell and Pedrini to a farm owned by Pedrini's brother near the town of Winters, in Yolo County (northeast of the Napa Valley). When they arrived, Pedrini's brother, Emil, told the officers that Bell and Pedrini had borrowed his car, supposedly to drive back to Napa. After a day of checking the roads, the officers returned to Winters. This time, Emil said Frank was at the ranch. The officers again questioned Pedrini, who continued to deny any involvement in the crime. The lawmen did note some bloodstains on Pedrini's pants and on the interior of his brother's car. Pedrini

claimed it was from an injured horse. Pedrini said he had dropped Bell off in Sacramento, supposedly so Bell could catch a train to Ohio. Undersheriff Gaffney convinced Pedrini to agree to accompany them to Sacramento to try to find Bell; however, just before leaving, Pedrini said he needed to go into the barn to retrieve a sweater. After Pedrini failed to come back, Undersheriff Gaffney and Deputy Graham went inside to investigate. They were met with a hail of rifle fire and shouts of "Get out of here, you sons of bitches!" The lawmen fired a few return shots with their pistols and then beat a hasty retreat. They drove to a nearby farm to call the Yolo County sheriff for backup and heavier firepower. When they returned to the Pedrini farm with reinforcements, Bell and Pedrini were long gone, fleeing on foot through the fields.

Bell and Pedrini surfaced several weeks later when a teenager, Lester Hansboro, reported that two men flagged him down while he was driving through Pacheco Pass, east of Gilroy. The men kidnapped him and forced him to drive them toward Sacramento, finally throwing Hansboro from the car near Davis. This turned out to be the last of seven such carjackings the duo had perpetrated up and down the Central Valley. Later that night, Bell crashed the car into a drainage ditch in West Sacramento. He stumbled into a Sacramento hospital with a skull fracture and registered using an alias. An alert nurse in the emergency room connected Bell's wet clothing with newspaper accounts of the crashed stolen car. Once Bell was identified, he gave a full confession. He fingered Pedrini as the instigator of Acquistapace's robbery and the one who assaulted the victim. He claimed that after Pedrini beat Acquistapace into unconsciousness, said, "That guy knows me. We have to finish him." And Pedrini proceed to kick Acquistapace further.

In the meantime, a joint Yolo and Napa County posse closed in on Pedrini, who had fled from the crash in West Sacramento and was holed up in a shack near the causeway that connects Yolo County with Sacramento. When cornered, Pedrini drew a revolver but was quickly disarmed and taken into custody. He was lodged in the Solano County jail in Fairfield. He was kept there because of fears that Napa Valley residents might lynch him. Undersheriff Gaffney obtained a confession from Pedrini as well.

Bell and Pedrini were charged with first-degree murder, burglary and robbery. They initially entered pleas of not guilty by reason of insanity. There was talk around town that the death penalty would be sought. In the end, Napa County district attorney Mervin Lernhart agreed to a

SHERIFF'S OFFICE, NAPA, CAL.

NAME Frank Pedrini
ALIASES
DATE ARRESTED Nov.18,1935 OFFICER Gaffney & Iraham
DATE HELD Nov. 18, 1935 JUDGE
DATE TRIED Nov. 28,1935 JUDGE King
SENTENCED Nov. 28,1935 PRISON Napa Co. Jail

COLOR White
DESCENT Italian
CRIME 1st Deg.Burglary
BOND 1st Deg.Robbery
RESULT 1st Deg. Murder
EXPIRES

Order | MARKS, SCARS, MOLES, DEFORMITIES, ETC.

FOLSOM

Burglary and Robbery sentenced to
of years prescribed by Law - run
consecutively
1st Deg. Murder for the term of
his natural life - no parole or

RECORD pardon. Run consecutively with
the sentences of Robbery and
Burglary.

DESCRIPTION

Height	5' 7½"
Weight	160
Complexion	Medium
Color Hair	Dark Brown
Color Eyes	Blue
Build	Stocky
Teeth	
Beard	
Age	28

Prisoner's Signature.... *Frank Pedrini*
Address.... 12/7/1935
Date....

Frank Pedrini's 1935 Napa County sheriff's booking photograph and information. *Courtesy of the Napa County Sheriff's Department.*

plea bargain, sending both Bell and Pedrini to Folsom State Prison for life. The change in course concerning the prosecution perhaps was due to the fact that the credibility of the man who found Acquistapace had been compromised. Archie Emery admitted to being an accomplice with Bell and Pedrini when they had burglarized the same store about a month before the robbery.

During the sentencing, District Attorney Lernhart told presiding judge Percy King that he had assurances from the State Board of Prison Terms that if the judge recommended Bell and Pedrini get life sentences, those wishes would be respected. It turns out a life sentence translated to only sixteen years thanks to the State Board of Prison Terms' parole policies.

Before the court proceedings were over, Pedrini promised, "If it takes twenty years, I will come back here and kill all of you."

Even before Pedrini was paroled, he made his own bid for freedom in 1943. Pedrini and a fellow inmate named William Smith had jobs in the prison's plumbing shop. They stole bits of pipe and fittings a little at a time, constructing a makeshift ladder. They were able to climb up the ladder into their cell's ventilation shaft and cut a hole about ten feet off the ground to access the prison's exercise yard. Under cover of darkness and with the rest of the prisoners at a scheduled movie, the escapees sprinted for a power canal behind the prison. The next morning, guards found a set of discarded prison garb on the far side of the canal and began an intense manhunt of the neighboring cliffs that snaked along the nearby American River. Pedrini and Smith enjoyed their freedom for two days until they were caught hiding in the tall grass that lined the river about twelve miles from the prison. Unfortunately, this wouldn't be the last the public heard of Frank Pedrini.

In December 1951, the State Board of Prison Terms deemed Pedrini reformed and released him on parole despite the strenuous objections of Napa County sheriff John Claussen. Pedrini immediately returned to his former avocation: strong-arm robbery. In 1953, he robbed and beat a gas station attendant in Sonoma County and was one of a group who beat and robbed a storekeeper in Hollister. Pedrini's crime spree and the threats he made toward the judge and district attorney during his trial prompted Sheriff Claussen to issue a "shoot to kill" order should any of his deputies spot Pedrini in the Napa Valley. When asked about its actions, the chairman of the State Board of Prison Terms said, "You can't tell that a man will go sour, like Pedrini, but murderers have our best parole records, and we take into consideration the best measurements of the human mind now available."

Pedrini would make his final mark not in the Napa Valley but on a lonely road straddling California and Nevada. In October 1953, Pedrini and a former cellmate, Leroy Linden, set up an ambush just west of Reno to steal a car. Clarence Dodd, a carpenter from Winnemucca, Nevada, stopped, thinking the duo needed assistance. When Dodd failed to arrive at his planned destination of San Diego, a missing person's report was filed. Five days later, Dodd's stolen station wagon was found burning on the side of a road just outside Texarkana, Texas. It would take another month before a young boy hunting rabbits would spot Dodd's body, buried under a pile of rocks in a shallow grave near Reno, a length of rope still wrapped around his neck.

Pedrini and Linden parted ways after returning from Texas. Linden was picked up in Los Angeles by FBI agents. Pedrini was betrayed by his own body. He turned up in Ukiah, where he went to the hospital for a bleeding ulcer. As he was being transported to a hospital in Santa Rosa, the ambulance driver recognized him from newspaper accounts. In a repeat of how Bernard Bell rolled over on Pedrini, Linden admitted being an accomplice to Dodd's murder but claimed that Pedrini was the instigator and that Pedrini had walked Dodd behind some rocks near the highway and returned alone a short time later, claiming that he had to kill Dodd because Dodd might have identified him from his distinctive tattoos.

In July 1954, Pedrini and Linden became the only dual execution in the history of Nevada's gas chamber, at the request of the pair. Unrepentant until the end, Pedrini joked with the guards and taunted Linden. Just before being strapped onto the gurney in the gas chamber, he told Warden A.R. Bernard, "Warden, you've been swell. I've been a heel all my life."

CHAPTER 17
A WILD RIDE

Napa of the late 1940s was a town in transition. Before World War II, it was a sleepy community within a sleepy agricultural valley primarily known for its prune orchards and as a destination for weary Bay Area citizens escaping to the valley's many resorts and spas. This was in an era before commercial air travel was as convenient or comfortable. All that was about to change with the advent of the jet age. But before the world became so connected, Bay Area residents would hop on the ferry from San Francisco to Vallejo and then catch a train or bus to the Napa Valley.

World War II transformed Napa. The most notable change was the influx of workers needed to man the factories of the Basalt Company, a steel plant that was retooled to churn out one of the most important tools used to support the war effort: ships. Whole residential neighborhoods—such as Shipyard Acres south of Napa and Westwood in the west part of town—sprang up overnight. The war also brought a steady stream of servicemen eager to spend a weekend pass drinking and dancing in one of the many bars that lined Main Street. The wife of a police officer who served more than thirty years on the force recalled that the war years were the only time when she worried about her husband's safety. She recalled him coming home from work more than once with a torn uniform, the evidence of the physical nature of keeping order among the inebriated. In fact, the problem became so bad that the police department had to hire back retirees to bolster the force and also enlisted the aid of the navy's shore patrol, which walked the downtown beat alongside Napa's finest. The city returned to a relatively

calm, quiet community after the war. The quiet calm of one early winter Sunday in 1948 would soon be shattered by the sounds of gunfire and the screeching of tires, part of one of the most brazen crimes in Napa's history.

John DeLaCasa seemed predisposed to flee from the police behind the wheel of a car. His life of crime began in St. Louis, Missouri, where as a cabdriver he acted as getaway driver and lookout for a pair of house burglars. He soon graduated to bank robberies and safecracking, never staying in one city too long or keeping the same partner for any period of time. By the time he hit Napa with his latest partner, Thomas Fargo, DeLaCasa had done two stints in prison. Like many criminals, he made the most of his time in the pen, educating himself on the fine points of safecracking. In the month before arriving in Napa, DeLaCasa and Fargo had cracked safes in San Francisco, Oakland and San Jose. They stole a new car from a garage in Frisco and headed up to the wine country.

William Thornton was a typical Napan, and his keen observation would set in motion a series of events that awakened Napa from the slumber of its postwar years. Thornton called the police station to report some suspicious characters changing the license plates on a sedan parked near his home. Thornton was so concerned about what he saw that he hopped in his own car and followed the suspicious vehicle downtown until it parked on Coombs Street, adjacent to the courthouse (across from the sheriff's office and one block west of the police station). In fact, Thornton needed only to walk that distance to update the police. Officer John McGlynn walked to the now-unoccupied car and staked it out. After a few hours, McGlynn was relieved by Officer Willis Hill.

Hill wasn't there five minutes when DeLaCasa and Fargo walked up to the car. Hill got the jump on the men and enlisted the aid of McGlynn and Chief of Police Eugene Riordan to grill them. The driver identified himself as "John Morgan" and produced a valid Michigan driver's license to prove it. While this jibed with the Michigan plates now on the car, the men couldn't explain why they also happened to have a set of California plates registered to someone from Santa Cruz. Sensing something more nefarious was afoot, Chief Riordan ordered the men brought to the station for further questioning. Hill climbed into the front seat with the driver, Morgan (who proved to be John DeLaCasa), and McGlynn got into the back with the other man, Thomas Fargo; neither subject was searched or handcuffed. Unfortunately, the lax procedures of the officers would have dire consequences.

Evidence collected from the car of Thomas Fargo and John DeLaCasa would later prove their chosen vocation: safecrackers. *Courtesy of the Napa Police Historical Society.*

As the car turned from Coombs onto Second Street, DeLaCasa shouted, "This is it!" and the desperados drew guns. In a split second, the loud report of DeLaCasa's Colt .45 echoed through the car as the bullet ripped into Officer Hill's thigh. Officer McGlynn quickly pulled his own revolver, beating Fargo to the punch. McGlynn emptied five rounds into Fargo, taking him out of the fight. What ensued was a mad struggle as both Hill and McGlynn grabbed at DeLaCasa, causing the car to careen like a pinball off parked cars on both sides of Second Street before finally thudding to a stop near Brown Street. The whole incident lasted less than a minute and played out in the space of one city block.

The unhurt DeLaCasa wasn't going to be captured that easily. He jumped out of the wrecked car and fled down Brown Street, unknowingly running directly into the path of the police station. Officer McGlynn leaped from the car and fired his remaining round at him. By this time, Sergeant Jule Ojeda

had heard the commotion and stepped outside the station just in time to see DeLaCasa sprinting by. Ojeda emptied his service revolver at DeLaCasa. Unfortunately, none of the bullets found their mark, and DeLaCasa ducked around the corner at Third Street.

DeLaCasa then found his means of escape: a car waiting for the traffic light at Third and Main Streets. He forced the driver out, effectively "carjacking" the car many decades before the term was coined, and headed south on Soscol Avenue.

By this time, the police had regrouped and gave chase with one police and one sheriff's car; the California Highway Patrol would help in the manhunt. The cooperation by local law enforcement was common at the time, as it still is today in Napa. Since each agency fields relatively small numbers of officers at any one time, when a major event happens, all the agencies pitch in.

DeLaCasa at this point made it clear he wasn't a local because he turned down a dead-end street behind the local Wright Spot eatery and onto a road that skirted the eastern shore of the Napa River. Finding his way blocked, he again fled on foot. Near the railroad tracks that hug the bank of the river, DeLaCasa came face to face with a reserve deputy sheriff named George Gordon. What ensued was a shootout that rivaled the best western showdown; the men squared off at ten paces and opened fire at each other. Deputy Gordon was on the receiving end of a bullet to his leg and crumpled to the ground. DeLaCasa pounced on him, wresting the deputy's revolver from his hand. Luckily for Gordon, DeLaCasa was more interested in making a clean getaway than finishing Gordon off. DeLaCasa ran off down the riverbank. DeLaCasa again displayed his ignorance of the area by commandeering yet another car and having to abandon it also a short time later by turning down another dead end near the river.

The third time was the charm for DeLaCasa as he again pulled yet another innocent motorist from a car at the intersection of Soscol and Imola Avenues. DeLaCasa this time turned eastbound onto Imola, skirting along the northern edge of the state mental hospital. The sheriff himself, John Claussen, and longtime highway patrolman Melvin Critchley were by now in hot pursuit.

The chase snaked its way back north, ending at the Tulocay Cemetery off Coombsville Road. Tulocay is Napa's historic cemetery, bounded by thick stone fencing along its perimeter and iron gates at its entrances. The officers set up road blocks at the two exits to the cemetery and prepared for a battle.

A Wild Ride

When DeLaCasa came into view driving the stolen car, they opened up, with Claussen peppering the car with his tommy gun. The remnants of the gun battle are still visible today; a large bullet hole can be seen in the door of one of the mausoleums. DeLaCasa continued to display an uncanny lucky streak by escaping unscathed, crawling from the Swiss-cheesed car and slipping the roadblock by scampering over a rock wall to a neighboring street. He would carjack one more car after first breaking into a home to secure a change of clothing and use the car as a means of finally escaping the long arm of Napa County law enforcement. Despite a massive manhunt and roadblocks thrown up around the county, DeLaCasa managed to slip the noose. This was a feat in itself, since there are really only a few roads into and out of the county, and local cops are very adept at clogging those routes. DeLaCasa abandoned the last stolen car in Vallejo; he wouldn't be heard from again for over a year.

The newspapers immediately identified the criminals as "yeggs," a slang term of the day used to describe safecrackers. The mere fact that there was a slang term created is a good indication of just how prevalent this type of crime was at the time. The tools recovered from DeLaCasa and Fargo's original stolen vehicle reveal that safecracking didn't always measure up to the movies' idealized interpretation of a highly skilled criminal using technique and finesse to defeat the safe. More commonly, petty criminals raided their tool chests or construction sites to find implements capable of applying brute force. The FBI joined in the manhunt for DeLaCasa after some of the guns recovered from the vehicle turned out to be stolen from the U.S. Army.

After lying low at a ranch outside Las Vegas purchased with ill-gotten gains, DeLaCasa returned to the Bay Area, hooked up with a new crew of safecrackers and resumed looting the area. He decided a change of scenery was needed, so DeLaCasa and his partners headed to Southern California in early 1949.

On January 25, 1949, his luck ran out. A Los Angeles police traffic officer noticed DeLaCasa driving a car listed in a bulletin as being a suspicious car. Never one to go easily, DeLaCasa led the officers on a wild chase down the Sunset Strip before crashing and taking off on foot. He ran and shot at the two pursuing officers as he fled, wounding each of his pursuers. DeLaCasa finally was cornered in the shed of a residence. DeLaCasa had vowed to never return to prison, and he was true to his word. In a scene worthy of one of the cops and robbers movies being churned out in nearby Hollywood, DeLaCasa flung open the door and began firing. He winged one officer before he fell, riddled with dozens of bullets.

WANTED

FOR ASSAULT TO COMMIT MURDER

John J. De La Casa
John J. delacasa alias
John Ross
John Morgan
Jack Drake
Jack Dale
Jack De La Casa

F.B.I.		#280833
McNeil Island	UN	8235
Colorado St. Penn		17641
U.S.P. Lynwth. Kan.		30854

F.P.C. $\frac{25}{17}$ $\frac{-}{A}$ $\frac{12}{12}$

Ref. $\frac{9}{17}$ $\frac{U}{A}$

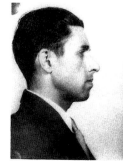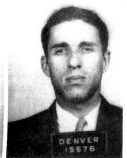

Description: White, Male, 43 6-1/2 180 Hair dark, Eyes dark.

WANTED for the shooting of two Police Officers here. October 17, 1948, at Napa, California.

We hold felony Warrant.

Bail $150,000.00 Cash $300,000.00 Surety.

Arrest, hold, wire collect. We will extradite.

Use extreme caution in apprehending.

EUGENE C. RIORDAN
Chief of Police
Napa, California

The wanted flyer for John DeLaCasa that Napa police chief Eugene Riordan distributed. *Courtesy of the Napa Police Historical Society.*

Napa police officer Hill and Sheriff's Deputy Gordon recovered, although Hill never fully regained use of his leg, and he retired from the force in early 1950. He kept one of the Colt .45s recovered from DeLaCasa and Fargo's car as a souvenir. Unfortunately, the gun was stolen in Vallejo many years later after being passed down to Hill's son.

The events that shook a sleeping Napa awake in 1948 were covered extensively in the Bay Area press. They also would be immortalized in an issue of *Headquarters Detective* magazine, one of many true crime periodicals of the time.

CHAPTER 18
A TOWN'S INNOCENCE LOST

The murder case of Doreen Heskett started out like many missing child reports: a five-year-old girl overdue returning home from a play date with a neighborhood friend. Of the thousands of missing children reported to law enforcement each year, 99.9 percent of the cases are resolved within hours with the child's safe return home. Many times, children have been picked up by another adult relative, unbeknownst to the reporting parent. Even more often, a young child decides on his or her own to go to a friend's house without the parents' knowledge. Some are even found hiding inside their own homes. Unfortunately, Doreen would fall within the .1 percent and, in doing so, would shake the safe and secure feeling of Napa in the 1960s.

Doreen Heskett was the second youngest of Mervin and Dorothy Heskett's nine children. March 25, 1963, started off as a normal day for Doreen. She attended kindergarten until noon and then came home at lunch and took an afternoon nap. In the afternoon, Dorothy went to the grocery store. When she pulled into the driveway after her trip, several of her children swarmed her, as would be common when a mother has nine children all under the age of eighteen. Doreen begged her mother to let her walk to Linda Ford's house. Dorothy knew that Linda was one of Doreen's classmates in kindergarten and that Linda had played at the Heskett house on several occasions. Doreen had asked several times in the past for permission to go to Ford's house; today, Dorothy finally acquiesced. She last saw Doreen skipping off with Ford at about 4:00 p.m. At the time, Dorothy was unaware that Linda

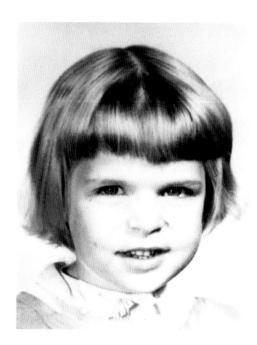

Doreen Heskett as she appeared in 1963, when she disappeared. *Courtesy of the Robert E. McKenzie Collection of the Napa Police Historical Society.*

actually lived on Sheridan Street, almost one mile away and across one of the busiest north–south thoroughfares in the city, Jefferson Street.

Doreen and Linda played together until about 5:00 p.m., when Linda's mother told her to walk Doreen home. They walked together about half the distance home, to the intersection of Jefferson Street and Pueblo Avenue. At that point, Doreen kept walking south on Jefferson Street instead of turning onto Pueblo, which would have been the most direct route home. Linda called to Doreen, "That's not the way to go." However, Doreen continued to walk south. It was later learned from witnesses that Doreen was last seen at about 5:15 p.m. walking in front of the Union Oil bulk plant on Jefferson Street, a few blocks south of Pueblo Avenue. Then she vanished, as if she had dropped off the face of the earth.

The search for Doreen was unprecedented in Napa County history, both before and since. It involved bloodhounds, scores of citizens including Boy Scout and Sea Scout troops, mobile ham radio operators, hundreds of national guardsmen and an air force helicopter from nearby Hamilton Air Force Base. City public works crews checked wells and storm sewers. Dozens of volunteer civilian divers searched the creeks in the area. Local gas stations donated gas to fuel the search efforts. Housewives kept a steady stream of donated meals on hand at the local national guard armory to fuel the searchers. In the end, it was estimated that more than five thousand people participated in the search for Doreen, to no avail.

Detectives diligently followed up on every lead. Over two hundred registered sex offenders were checked out between Napa and neighboring

The bleachers of Napa's Memorial Stadium were filled with volunteers, both civilian and military, ready to become part of the search party for Doreen Heskett. *Courtesy of the Robert E. McKenzie Collection of the Napa Police Historical Society.*

Sonoma and Solano Counties. The overstretched officers of the Napa Police Department worked night and day on the case. The police even asked for help from two nationally known psychics. Both had "impressions" about the missing girl (neither of which would turn out to be accurate).

The missing person's case of Doreen Heskett would remain unsolved for almost eight months, until the morning of November 21, 1963. Rancher Earl Stewart was surveying a hay field on his ranch to determine if it was too wet to plow. The field was covered with about ten-inch-high hay stubble. Stewart noticed a dark area just a few yards away from the dirt road. He investigated and discovered the badly decomposed body of little Doreen. Earl Stewart's ranch was at the far south end of town, past the southerly terminus of Jefferson Street, about three miles from where Doreen was last seen alive.

After the body was discovered, the scene was roped off and the elected coroner, Charles "Cap" Burchell, was called in. Since the Napa police didn't have a forensic unit at the time, a private criminalist from Berkeley, Charles Morton, was called in to process the scene. Morton was the protégé of Paul Kirk, the University of Berkeley professor who literally wrote the book on modern crime scene forensics. The remains were mostly skeletal; the skull had been crushed, which was attributed to cattle that had been grazing in the field. The position and condition of the clothing present led detectives to

surmise that Doreen may have been sexually assaulted. The other odd fact was that Doreen's shoes and stockings were missing, even though the bones in her feet were intact.

A coroner's inquest was held in August, led by Coroner Burchell, in which a panel of nine jurors heard evidence about Doreen's disappearance, the discovery of her body and the results of the autopsy. Napa County district attorney James Boitano questioned various witnesses about the case, including little Linda Ford. A forensic pathologist testified that he observed a pre-mortem (before death) injury to Doreen's jaw. The jurors determined that Doreen had died by unknown means at the hands of party or parties unknown and ruled the death a homicide.

The location of Doreen's body leads to two conclusions: first, that she could not have walked to the location on her own, and second, that most likely someone familiar with the ranch placed her body at the site. Stewart's ranch was separated from the dead end of Jefferson Street by two other ranches, several drainage ditches that were six feet deep and barbed-wire fences. It would have been impossible for a five-year-old girl to walk three miles to the ranch and then traverse these obstacles. The remoteness of the area and the difficulty in reaching it by vehicle point to the site being familiar to whoever dumped Doreen's body there.

Two years after Doreen disappeared, two other young girls, Jeanette and Renay Ray, vanished one morning. The girls' father, Claude Ray, claimed he had dropped them off in front of their elementary school. The truth wouldn't be known for a week, until one of the girls' bodies washed up along the shore in Mendocino County. The investigation revealed that Ray had driven the girls to the coast, strangled them and thrown them over the edge into the ocean. His motive: a messy divorce. Suspicion fell on Ray as possibly being responsible for Doreen's death. This theory was bolstered by the fact that Ray's youngest daughter and Doreen had been in the same class in school. No conclusive evidence was ever located pointing to Ray, and the nature of Ray's crime doesn't match the facts of Doreen's killing.

The murder case of Doreen Heskett remains unsolved to this day. It is one of more than two dozen unsolved homicides in the Napa Valley that vexed detectives and citizens alike. Locals who were around in 1963 remember that it was the year that Napa's innocence was lost, along with Doreen.

CHAPTER 19
A DAY AT THE LAKE TURNS DEADLY

A series of murders committed in the San Francisco Bay Area during 1968 and 1969 are probably the best-known unsolved murders in U.S. history. Dozens of movies, documentaries, true crime books and websites have been devoted to the crimes. The killer became known as the "Zodiac" because of letters and coded ciphers he sent to local newspapers, taunting the police and threatening more violence, signed "the Zodiac." The Zodiac himself claimed to have killed thirty-seven people, and amateur detectives have tried to link him to other murders and famous crimes such as the Black Dahlia murder in 1940s Los Angeles and the Chicago Lipstick Killer in 1945. The hard evidence has linked the Zodiac to four separate incidents, all within the Bay Area, in which a total of five people were killed.

The first two attacks happened at isolated locations in Solano County, just east of the Napa Valley. The locations were typically used as "lover's lane" destinations for couples. On December 20, 1968, two teenagers, David Faraday and Betty Lou Jensen, were shot and killed in their parked car on Lake Herman Road near Benicia. On July 4, 1969, Michael Mageau and Darlene Ferrin were shot in their parked car at Blue Rock Springs Park in the city of Vallejo. Ferrin was killed, but Mageau survived.

On September 27, 1969, Brian Hartnell was spending the day with a former girlfriend named Cecelia Shepard. Both had attended Pacific Union College, a Seventh-Day Adventist institution located in Angwin. They had no idea that they would become the Zodiac's next victims. In fact, had their plans worked out, they would have never met the Zodiac. The couple had

originally planned to pick up a used television in Calistoga and then drive into San Francisco for a visit. Unfortunately, Brian's two-seat Volkswagen Karmann Ghia wasn't big enough to fit both the TV and Cecelia, so Brian had to drive the TV back to the college and then return to Calistoga to pick up Cecelia. By this time it was late afternoon, so the couple decided to drive to the Lake Berryessa area instead of San Francisco. Lake Berryessa was, and still is, a favorite recreation destination in Napa County. Situated on the eastern edge of the county, it borders neighboring Yolo County. The lake was created when the Putah Creek was dammed in 1957.

The couple found a turnout and walked down a dirt trail to a spit of land

with a few trees that jutted into the lake. They enjoyed their time at the lake until shortly after 6:00 p.m. Cecelia was the first to notice something wrong. She commented to Brian that there was a man peering at her from behind a nearby tree. By the time Brian looked up, the suspect had donned a homemade hood and was rapidly approaching them. He was armed with a pistol in one hand and a knife in the other.

Brian, assuming the suspect was a would-be robber, attempted to engage him in conversation. It was a dangerous gamble since Brian had less than a dollar in change on him. He apparently didn't make the connection that the circle with cross emblem on the suspect's hood was the symbol the Zodiac had used in his taunting correspondences

A contemporary sketch of the man who attacked Cecelia Shepard and Brian Hartnell at Lake Berryessa. The use of the distinctive hood set this attack apart from other Zodiac attacks. *Courtesy of the Napa County Sheriff's Department.*

and ciphers sent to Bay Area newspapers. Brian even convinced the suspect to detach the magazine from the semiautomatic handgun to prove to Brian that the gun really had bullets in it.

The conversation Brian had with the Zodiac was unique among other Zodiac crimes. No other surviving victim ever reported talking to the Zodiac. The Zodiac told Brian that he had killed a prison guard while escaping from a prison in Montana and that he was seeking money and a car to flee to Mexico. Although there had been a well-publicized prison riot in Montana at Deer Lodge State Prison in 1959, the story told by the Zodiac was likely an ad-libbed tale meant to make him seem like a dangerous criminal to Brian and Cecelia to aid in gaining their compliance. This would seem to be borne out by the fact that the Zodiac didn't even look inside Brian's wallet, even though Brian had taken it out of his pocket, and made no attempt to steal Brian's car. Some amateur detectives have since tried to link the Zodiac case to several different convicted murderers who did time at Deer Lodge State Prison. However, no definitive evidence has been able to link them.

The Zodiac had Brian and Cecelia lie facedown on their blanket. He pulled out strips of pre-cut laundry cord and instructed Cecelia to bind Brian's hands behind his back. The Zodiac then did the same to Cecelia and tightened the bindings on Brian, which Cecelia had left loose. Methodically, the Zodiac then stabbed Brian six times in the center of his back. Cecelia, hysterical at the sight of this, would suffer even more as she tried to roll away from her attacker; she was stabbed in the front of her torso, on her back, on her arms and on her hand. The Zodiac then calmly walked off, leaving Brian and Cecelia for dead. In one final act of bravado, the Zodiac took out a marker pen and scrawled a message on the passenger door of Brian's car: the word "Vallejo" with the dates of the first two attacks, the current date and time and the words "by knife." He signed this perverse act of graffiti with the same signature he used in his letters: a circle and cross logo.

Brian and Cecelia called to several passing boats, with no results. Finally, as the last boat passed by, they cried for help again. The boat circled in the water once and then motored closer to the shore. The boater, Ron Fong, at first thought the man and woman were pulling a practical joke until he peered through his binoculars and saw they were covered in blood. Fong told the couple that he'd go get help and sped to the nearby Rancho Monticello resort to call for help. It was 7:00 p.m.

Napa County sheriff's detective Hal Snook processes Brian Hartnell's car for fingerprint evidence after finding a note from the Zodiac scrawled on the car's door. *Courtesy of the Napa County Sheriff's Department.*

Within a few minutes, Park Ranger Bill White arrived, and Fong took him via boat back to the scene. When they got there, all they found was Cecelia. While Fong was gone, Brian had mustered enough strength to crawl back to the roadway, collapsing just as a pickup truck with another ranger pulled up near his Karmann Ghia.

At 7:40 p.m., Napa police officer Dave Slaight was manning the phones at the police station when a call came in. At the time, it was common for officers to act as call takers and dispatchers after hours. A young-sounding male caller calmly stated, "I want to report a murder, no, a double murder. They are two miles north of Park Headquarters. They were in a white Volkswagen Karmann Ghia." When Officer Slaight asked the caller where he was now, a barely audible voice answered back, "I'm the one that did it." The police would later find exactly where the caller had been; a newspaper reporter discovered a dangling phone receiver at a pay phone on Main Street near Clinton Street in downtown Napa.

A Day at the Lake Turns Deadly

At 8:50 p.m., an ambulance brought Brian and Cecelia to the Queen of the Valley Hospital in Napa, the only trauma hospital in the valley. During the ambulance trip, Cecelia had lapsed into a coma. She died two days later. Brian, although badly wounded, made a full recovery, save the physical and mental scars of the attack.

The crime scene was processed by Hal Snook, a deputy who pioneered crime-scene processing at the Napa sheriff's department. Snook habitually carried a tobacco pipe similar to the style smoked by Sherlock Holmes. Indeed, in many crime scene photos, Snook can be seen in the background working diligently, pipe clenched in his teeth. It was Snook who discovered a trail of shoe prints in the dirt leading from the trail access gate to the side of Hartnell's car. These shoe prints would become a key piece of the Zodiac mythology. The shoe prints were determined to be Wingwalker military boots, size ten and a half. Detectives quickly learned that over 100,000 pairs of these boots had been issued or sold in military surplus stores. The fact that they were military boots bolstered the claim of many that the Zodiac had a military background.

The case investigation was led by Detective Ken Narlow, a no-nonsense cop who would keep the case throughout the rest of his career. Even after his retirement in 1987, Narlow still fielded calls and letters from tipsters and amateur detectives. He later acted as a technical advisor to the 2007 film *Zodiac*, which starred Jake Gyllenhaal and Robert Downey Jr.

One of only two composite sketches allegedly depicting the Zodiac was completed after three college girls contacted the Napa sheriff's department to report that a strange man had been staring at them for forty-five minutes while they were sunbathing on the same day Brian and Cecelia were attacked.

The Zodiac would last strike on October 11, 1969. This time he broke from his past modus operandi (MO), which had been attacks on young couples in isolated areas and on weekend nights. This time, newly hired cabdriver Paul Stine picked up a fare in downtown San Francisco and drove the man to the Presidio Heights neighborhood of the city. Instead of getting paid, Stine was shot in the head and killed. The Zodiac fled on foot. The widely distributed suspect sketch of a clean-cut man wearing glasses was made based on the sighting of two San Francisco police officers who saw him walking away from the area. In a strange twist of fate, at the time of the sighting, the all-points bulletin for Stine's killer erroneously listed the suspect as a black male; thus, the officers didn't stop or detain the man who

most likely was the Zodiac. The case was confirmed as a Zodiac crime when another letter was sent to a newspaper, this one with a bloody piece of Stine's shirt attached to it.

The Zodiac kept writing letters to law enforcement and local newspapers, including one infamous rant in which he threatened to target a school bus full of children. For weeks, law enforcement officers throughout the area provided escorts for school buses. The letters continued until 1974, and then all communication ceased. No other crimes after Stine's murder have conclusively been linked to the Zodiac. There are many theories as to why the Zodiac stopped killing, such as he had been committed to a mental hospital or sent to prison for an unrelated crime. Some believe he simply moved to another area and decided not to publicize his crimes anymore. Historically, serial killers rarely stop killing until they are caught or die. One exception to this is the now infamous case of the Bind, Torture, Kill (BTK) killer in the Midwest. Dennis Rader murdered ten women between 1974 and 1991 but then stopped killing and started the normal life of a husband and father.

Ever since the Zodiac crimes occurred, people have come forward with theories of who the Zodiac was. Many tipsters even suspected relatives, co-workers or neighbors. The coded cipher letters sent by the Zodiac have been interpreted by various tipsters to supposedly spell out their chosen suspect's name. A database of suspect names provided by tipsters to the Napa sheriff's department just in the last twenty years contains more than 250 names.

In 2010, the Napa sheriff and police departments secured a National Institute of Justice (NIJ) grant to apply DNA technology to unsolved cold cases such as the Zodiac case. Lacking a DNA profile, probably the only way the Zodiac case will ever be solved beyond a reasonable doubt is if a gun linked to the shootings or another piece of the bloody shirt from Paul Stine is recovered in someone's attic.

CHAPTER 20
THE CRIME THAT FROZE TIME

The scene of the crime was untouched for nearly four decades, a mute witness to the horror that happened in the middle of the night in 1974. Napa locals and tourists alike have asked countless times, "Why is that vacant bar there?" Even as Napa's downtown district on Main Street was redeveloped, as a gleaming Veterans Park was dedicated across the street and as flood control work replaced nearby bridges and created a river walk snaking along the banks of the Napa River, the bar at 813 Main Street remained shuttered, its front doors locked with a rusty chain and padlock.

Nicola Fagiani bought the building on Main Street in 1945 and opened a bar. The bar wasn't particularly interesting or unique at the time; Napa's Main Street was then thick with bars, frequented by locals and the many military personnel on liberty from nearby military bases. In fact, during World War II, the Napa police routinely patrolled the downtown area with U.S. Navy shore patrolmen in an effort to control the raucous revelry.

Nicola Fagiani died in 1969 and passed the ownership of the bar to his two adult daughters, Muriel Fagiani and Anita Andrews. By 1974, the bar was frequented by many locals, some of whom populated the rundown Conner Hotel across the street on the site of the current Veterans Park.

Anita Andrews wasn't your typical bar owner, although she had been raised helping her father in the bar's kitchen. In 1940, the then-seventeen-year-old Andrews had been crowned queen of the Napa County Fair. She later married, moved to Berkeley and had two daughters. When she divorced in the early 1950s, she moved her daughters back to Napa to be closer to

her extended Italian family and took a job as a secretary at the Napa state mental hospital.

After their father died, his daughters kept the bar open. They couldn't afford to hire employees, so the women worked their regular jobs during the day and staffed the bar at night. Such was the night of July 10, 1974, when it was Anita Andrews's turn to work at the bar.

The next morning when Andrews didn't show up for her day job at the Napa state hospital, her sister Muriel went looking for her. After checking Andrews's apartment, she drove over to the bar and made a ghastly discovery. She found the front door of the bar unlocked and discovered her sister lying on the floor of the back room, her clothes in tatters and her body bloodied by thirteen stab wounds. The murder weapon, a screwdriver, was lying next to the sink; it had been washed off in an apparent attempt by the killer to obliterate his fingerprints.

The interior of Fagiani's Bar as it appeared in 1974, the year Anita Andrews was murdered. The bar stayed as pictured, closed and locked up, for over thirty years. *Courtesy of the Napa Police Department.*

Detectives worked diligently on the case, trying to track down every patron who was in the bar the previous night. A private criminalist was brought in to process the scene. His efforts would prove critical decades later as the technology of DNA analysis advanced. He preserved cigarette butts in the ashtrays, documented a partial bloody shoeprint, collected several open beer bottles from the bar and found a towel with blood on it. Andrews's tan Cadillac was nowhere to be found. To this day, it remains a mystery what happened to the car. The only clue as to the suspect's actions after the crime seemed to be one transaction on Andrews's credit card at a gas station in San Joaquin County in the wee hours of the morning after she was killed. A clerk helped the cops produce a sketch of the person who used the card.

Muriel Fagiani kept the bar open for less than a year after the murder and then chained and locked the doors. It remained locked in time thereafter, beer bottles chilling in the cooler, half-empty liquor bottles sitting behind the bar, taxidermied animals hanging on the walls, bearing mute witness as the decades passed, until 2010.

Roy Melanson was born in 1937. His first recorded crimes occurred in 1956 in Louisiana. Like many lifelong criminals, Melanson would graduate from burglary and theft to more serious crimes. He became known as a smooth-talking con man, making his living off his wits and criminal wiles. For most of the 1960s, Melanson called Texas home. He served prison sentences for burglary and rape. In 1970, Melanson was released from prison after serving just over five years of a twelve-year rape sentence. In February 1974, Melanson was accused of raping another woman, this one in Orange County, Texas. Melanson was released on bail and promptly skipped the state, making his way to California.

By the time Roy Melanson bellied up to Fagiani's Bar in Napa on July 10, 1974, he had spent a third of his adult life in prison. He patiently waited for the regulars to drink themselves out of their money, all the while sipping a beer and smoking cigarettes at the bar. Melanson didn't know it at the time, but these actions would seal his fate thirty-seven years later. Finally, the last patron stumbled out the door, leaving Melanson alone with Anita Andrews.

Throughout Melanson's criminal life, two modus operandi would be repeated over and over again: Melanson used his charm and politeness to lull his victims into misplaced trust, and he was an opportunistic criminal; if a victim presented herself and appeared vulnerable, Melanson would take

Roy Melanson as he appeared in 1975 in an Orange County, Texas booking photograph. *Courtesy of the Orange County Sheriff's Department.*

advantage of the situation to satisfy his own needs, be they monetary, sexual or the means of continuing his travels.

Unfortunately, Roy Melanson's thirst for blood didn't end in Napa. By August 30, only about a month and a half after the Anita Andrews murder, Melanson had made his way to Colorado. He and a fellow drifter named Chuck Mathews crossed paths with Michelle Wallace at a hiking trailhead near the town of Gunnison. Wallace was a twenty-five-year-old Chicago native who was spending the summer in Gunnison, hiking and practicing her vocation, photography. Wallace gave Melanson and Mathews a ride into downtown Gunnison. Melanson then asked Wallace if she could give him a ride a few blocks farther to his truck. Mathews last saw the pair driving off together; it would be the last time Wallace would be seen alive. It was Wallace's practice to call her parents each Sunday; when the regular call didn't come, her parents filed a missing person's report. A five-thousand-plus-man-hour search was conducted in and around Gunnison, to no avail. It was as if Wallace had fallen off the face of the earth.

Melanson left one loose end: Chuck Mathews. When Mathews heard about Wallace's disappearance, he immediately notified the sheriff's department about last seeing her with Melanson. The authorities put out an all-points bulletin for Melanson.

Melanson was arrested in Pueblo, Colorado, two weeks later and questioned. Investigators learned that Melanson had pawned Wallace's camera and other camping gear; the camera still had undeveloped film inside of Michelle's last pictures and a final picture of Melanson with another woman in a motel room. Without a confession or a body, the district attorney declined to prosecute Melanson, and he was shipped back to Texas to stand trial for the February rape.

If not for the dogged determination of detectives both in Colorado and California, Melanson might still be killing unsuspecting women today. The case of Michelle Wallace was reopened by Gunnison County sheriff's investigator Kathy Young-Ireland in 1988. She worked at the case off and on for four years in between her other investigative duties. This is a common practice even today with law enforcement agencies. Unable to fund dedicated cold case investigators, they assign cold cases to regular investigators to work on when time permits among the never-ending stream of new cases coming across their desks.

Investigator Young did learn that Melanson had served only fourteen years of his supposed "life" sentence for the Texas rape; he was released in 1988. She also learned that less than six months after being released, Melanson had become the prime suspect in the disappearance and murder of a woman in Port Arthur, Texas. Melanson would later be linked via DNA to yet another homicide, the August 1988 murder of a woman in Livingston Parish, Louisiana.

Finally, in 1992, the break in the Michelle Wallace case came when her skeletal remains were found in the mountains outside Gunnison, with the assistance of the forensic anthropology firm NecroSearch International. Melanson was tried and convicted of Michelle Wallace's murder in 1993. It was the result of this conviction—the swabbing of Melanson's cheeks for a DNA sample and its upload into a nationwide database—that would crack the Anita Andrews case wide open.

In 2009, Napa police detective Don Winegar was another in a string of detectives who had been assigned to work on the Andrews case over the decades. By this time, Detective Winegar had amassed an impressive career during his more than thirty years as a cop; he had worked assignments ranging from patrol officer to field training officer, acting sergeant, SWAT

member and now, at the end of his career, detective. He was very familiar with the advances in DNA technology and had worked on several other cold case homicides. Detective Winegar's first action was to review the evidence that was preserved and send what he could to the California Department of Justice DNA Laboratory for analysis. The DNA match with Melanson came a few months later. He then began the arduous task of tracking down the witnesses who had been in the bar on the night of the murder. One of these witnesses, David Luce, picked Melanson out of a photographic lineup as being a fellow patron he had seen drinking and smoking in the bar.

Roy Melanson was serving a life sentence in Colorado when his DNA was matched to a cigarette butt discarded in Fagiani's Bar. Detective Winegar traveled to Colorado and interviewed Melanson, who denied ever being in Napa. "I don't even know where Napa is," he told Winegar. Melanson claimed he did not commit the crime, saying, "On my dead mother's grave. I'm not capable of it." Further DNA testing found Melanson's blood on a discarded rag left at the crime scene and preserved during the intervening thirty-five years.

The prosecution team was led by Deputy District Attorney Paul Gero. A veteran of several murder trials and an expert in child molestation cases, he had already sent many criminals to prison for life or for terms measured in decades. In the courtroom, he methodically unraveled the mystery of Anita

Andrews's murder using eyewitness testimony from now-elderly bar patrons and expert testimony from California Department of Justice DNA criminalists and a series of cops who investigated the crime, from the first responders in 1974 to the final investigative work by Detective Winegar.

The trial took eight days. Melanson sat quietly in the courtroom in shackles, in a wheelchair due to medical issues; he was a shell of the man who once drifted around the West taking advantage of people. David Luce testified that while at the

Roy Melanson as he appeared in 2010, when booked into the Napa County jail. *Courtesy of the Napa County Department of Corrections.*

bar, he shook hands with a man whom he and his friends had seen sitting alone at the bar, shielding his face with his hand and smoking a cigarette.

In addition to the DNA testimony, jurors heard from Napa police forensic specialist Janet Lipsey, who processed the beer bottles collected from the crime scene. She located more than a dozen of Melanson's fingerprints on the bottles.

In some of the most moving testimony, the heinous details of two Texas rapes that Melanson committed unfolded in front of the jury. A statement was read from the now-dead woman whom Melanson raped in 1972. Then the woman whom Melanson raped in 1974 testified. He had been on the run from this crime when he turned up in Fagiani's Bar.

The jurors then heard the tragic tale of Michelle Wallace's murder. Steven Fry, the former undersheriff with the Gunnison County Sheriff's Office in Colorado, detailed the extensive search for Wallace. Jimmie Smalley, a retired police captain from Pueblo, Colorado, testified about how he found pawn slips for Wallace's possessions, her driver's license and other items in Melanson's possession when he was detained in Pueblo in 1974.

The defense called but one witness, a DNA expert who tried to poke holes in the results that the Department of Justice criminalist had obtained. Melanson elected not to testify.

It took just under a day for the jury to return its verdict: guilty of first-degree murder. Melanson was sentenced to life in prison and then shipped back to Colorado to serve out his life murder sentence there. If by some quirk of law he were to be released or paroled in Colorado, he would be brought back to California to serve his sentence there.

In later life, Muriel Fagiani became a well-known gadfly at government meetings. She also never gave up hope that her sister's killer would be found and brought to justice. Every year, Muriel would come to the Napa police station to meet with the chief of police and push for the investigation to continue. She continued this practice as the tenure of three police chiefs passed. Muriel died in 2010, shortly after she was informed that a suspect had been identified in her sister's killing. A plaque in her honor was installed on her regular seat in the public seating area at the Napa City Council chambers. Fagiani sold the bar on Main Street in 2009; it is currently being remodeled, with plans to make it a restaurant.

Gary Lieberstein, the Napa County district attorney, summed up what this case was all about when he was quoted after the verdict as saying, "We don't forget about victims or justice because time goes by."

CHAPTER 21
THE OLDEST PROFESSION

A book about infamous Napa Valley crime wouldn't be complete without mentioning those crimes that aren't spoken of in polite society. Yet even when considering the more conservative morals of the last century, researching this book revealed many references to the oldest profession; perhaps the news media of that era also appreciated a sensational story as much as they do today.

The history of prostitution in the Napa Valley is inextricably tied to the neighborhood known as Spanishtown. The area was centered on Clinton Street, stretching from Main Street on the west to the current area of Soscol Avenue on the east. The area is just north of downtown, an easy walk for prospective customers. The ratio of men to women in early California ensured a steady stream would make the trek; when Napa County was formed, the population was 90 percent male. As the name suggests, Spanishtown had an ethnic concentration of those of Hispanic descent, although the area was also understood to be a safe haven for brothels and dance halls. Elderly Napans recalled for a newspaper reporter in the 1970s at least twenty such establishments on and around Clinton Street, the main thoroughfare through Spanishtown during its heyday. Prostitution was generally seen as a necessary evil, especially considering the lopsided ratio of men versus women during the frontier period.

Prostitutes in the West were primarily made up of three groups: the women who worked in brothels, those who were streetwalkers and those who worked in saloons and dance halls. Brothels were set up based on the

economic state of the clientele they serviced; many of us have a vision of brothels as portrayed in western movies, with stately Victorian mansions and women dressed in the best finery of the time. To be sure, there were brothels like these; however, there were also those that catered to men of lesser means, where the working conditions were less than ideal. Saloon and dance hall girls' primary jobs were not sexual in nature. They earned most of their money by getting their customers to drink and charged a fee per dance, receiving a percentage of the take from the owner.

Two particularly tragic stories bring the life of a prostitute into focus. The first involved Mollie Williams (alias Swartz). She was but eighteen years old when she met Henry Pierce while "working." Henry was the son of Harrison Pierce, a merchant who built the Empire Saloon in 1848, the first commercial structure in the city of Napa. We may never know what Mollie's real name was. Even Henry described this as being her "town name," an allusion to the fact that many prostitutes used aliases. Later, Henry would claim to know only that she was about eighteen years old, that she was from San Francisco and that she had been in the Napa Valley for only about seven months. He convinced Mollie to give up her profession and marry him. They first moved in together and lived for about six months before he moved her to his sister's house, apparently to make their engagement period more respectable. This arrangement lasted for about two months.

On Sunday afternoon, May 9, 1875, the relationship between Mollie and Henry would explode in the middle of Spanishtown at the intersection of Clay and McKinstry Streets (presently located between the site of the Napa Wine train station and the trendy Oxbow Public Market). Henry was at his job as a stableman feeding horses for Thomas Algeo. Newspapers of the time reported that Mollie learned that Henry was "dissipating," a possible allusion to being intemperate (drunk), and went to the stable to bring him home. Witnesses reported seeing the two quarreling, and then Henry fled on foot from the area. Mollie was found lying in the street, a mortal knife wound to her thigh. She was carried to a nearby house, where doctors discovered that her femoral artery had been cut.

Henry was stopped by Dr. Colman, who had been called to the scene for the coroner's inquest. Colman initially thought Henry might be a witness, but Henry was quickly identified and taken into custody by Constable William Baddeley. Justice of the Peace Towle discovered the murder weapon discarded in the bushes near the scene; it still had blood on the

blade. When questioned, Henry claimed that Mollie came running over to his workplace and fell into his arms. He said it was only then that he noticed she was bleeding.

Two days later, Henry's preliminary hearing was held. Unfortunately for Henry, there were two eyewitnesses—men employed by a nearby tannery—who were sitting on the front porch of their workplace, not two hundred feet from the scene of the crime. They reported first hearing the argument between Henry and Mollie and then saw Henry slap her. Henry walked away and leaned against a fence line, apparently trying to compose himself; however, he turned back around, walked back to where Mollie was standing and stabbed her once with a knife. After the stabbing, Henry was seen running to the nearby residence of a Mrs. Moore. He returned a few minutes later with the woman. It would take only the testimony of the two witnesses for the justice of the peace to hold Henry for trial.

In October, Henry finally had his day in court. His version of the incident had changed markedly since he was questioned in May. During his testimony, Henry admitted going to the Live and Let Live Saloon on the day in question and drinking three or four whiskeys and three or four beers before heading over to Algeo's corral to feed the horses. Henry also admitted that Mollie came to the corral, complaining that he was drunk and trying to convince him to come home with her. They argued about just how drunk he was, and he refused to go with her, claiming that he had to finish feeding the horses. Henry also admitted lightly slapping Mollie on the face and brandishing a knife in an attempt to scare her into leaving. Henry said the knife accidentally got too close to Mollie, cutting her.

The jury deliberated for almost two full days, a length that surprised many courtroom observers who assumed a guilty verdict was beyond question. It turned out the jury had struggled with which degree of murder Henry was guilty of, with some on the jury not believing that he had intended to kill Mollie. The verdict of second-degree murder was returned. A few days later, Henry was sentenced by Judge Wallace to twenty years in prison. A reporter for the *Napa Daily Journal* noted that Henry showed little emotion during the trial, save the twitching of his fingers during the sentencing. He was promptly carted off to San Quentin State Prison by the sheriff. So ended but one of the many tragic tales of soiled women caught up in the wiles of Spanishtown.

The second tragic story occurred in 1906, just two months after the great earthquake shook the Bay Area and leveled San Francisco. This story had

all the elements that made good headlines: salacious details and a murder-suicide involving a prominent family of the Napa Valley.

Roy Spurr was the son of Logan Spurr, a constable in St. Helena. Roy worked as a foreman for the Napa Valley Railroad. He fell in love with a woman named Carrie Clark, who worked at a house of ill fame at 1 Clinton Street. Clark had plied her trade in Napa for about two years by the time she and Spurr began a relationship.

Two other women who lived and worked at the house later testified during a coroner's inquest about what happened on June 11, 1906. Two gunshots pierced the quiet of the night at about 11:00 p.m., followed quickly by screams from Carrie and then two more gunshots. The women rushed to Carrie's bedroom and found both Carrie and Roy dead on the floor. The only eyewitness was a man named Marshal Thomas, who had walked Carrie to the house from a neighboring residence. Newspapers of the day suggested this was the possible motive: jealousy. The theory was that Carrie was too friendly with Thomas, and this caused Roy to snap. Thomas and Carrie had been talking when Roy barged into the bedroom, immediately leveled a revolver at Carrie and fired. The first shot entered her left forearm and the second tore through her head, exiting at the back of her throat. Thomas then wrestled with Roy before Roy was able to break free and put the revolver to his own temple, ending his life as he slumped onto the floor next to the love of his life.

Napans had a love-hate relationship with the oldest profession. Reviewing local newspaper archives, one finds various attempts through the years to deal with the houses of ill fame. In 1908, Napa County district attorney Silva announced he would vigorously prosecute brothel madams' prostitutes, described as their "inmates," under Penal Code Section 315, a section that is still on the books and makes it a misdemeanor to keep or live in a house of ill fame. He drew up notices giving the women two days to leave the county or face arrest. Silva had Undersheriff James Daley serve the notices at the three brothels operating in Napa; Daley also found and served two Japanese women who were operating in the town's Chinatown. At the same time, the constables of St. Helena and Calistoga each served notices on bordellos in their cities. This crackdown apparently was short-lived.

There was another effort to eradicate prostitution in 1918, when Prohibition advocates pushed for enforcement of the state's Red Light Abatement Law, which had been on the books since 1914. The law and prostitution itself

were largely overlooked by local law enforcement. Again, once the fervor died down and a few fines were paid, the madams resumed business as usual.

Of the "traditional" brothels in the Napa Valley, several had reputations that have survived the decades. Perhaps the most famous bordello in Napa was a Spanishtown establishment located on Clinton Street, on the side of present-day Soscol Avenue. The house was razed to make way for the northerly extension of Soscol Avenue in the middle part of the last century. This particular brothel was run by a madam known as May Howard; research has revealed that her true name was Mayme Smith. She ran this bordello for several decades, ending in 1937, outlasting most of her counterparts. Old-time Napans recall May and her girls shopping in pairs for dresses in downtown Napa's finest mercantile shops. May had a policy that no one in uniform was allowed into her house, so extra sets of clothes were kept at a nearby bar to allow for quick changes. Apparently, the death knell for May was one or more of her patrons being robbed while coming and going from her house. The Napa police could no longer turn a blind eye and finally shut May down. In an odd twist of fate, future Napa County district attorney James Boitano purchased May's former bordello. Boitano later recalled that when he was a child, May would stop by his family's market, located near the bordello, and pay off the outstanding accounts of her Spanishtown neighbors.

In contrast to May's upscale establishment, there were several other Napa brothels noted in historical documents. These include one run by a madam named China Mary, located in Napa's Chinatown. This area had a sketchy reputation like that of Spanishtown. Police blotter reports in newspapers frequently described raids of opium dens and illegal gambling houses there. Another brothel was run for a time on the second floor of 1245 Main Street at the intersection of Clinton Street. Many local residents know the building as the Sam Kee Laundry, a business it housed for many years. Today, in keeping with Napa's redefined image, the building houses a wine bar.

The second brothel that outlasted most others was the Stone Bridge, located on Silverado Trail near Pope Street, east of St. Helena. A Prohibition-era crusader in the 1920s named Edwin Grant described it thusly:

> *One of the toughest characters we have had to deal with was Mary Selowski, of Napa, an immigrant from Russia. Mary Selowski ran the Stone Bridge house near St. Helena. Scores of girls went down to their doom in the house kept by this foreign woman. So contemptuous of the law was she that we had*

The Pfeiffer building, located in Napa at 1245 Main Street, was originally built as a brewery in 1875. During the heyday of Napa's red-light district, the second story was reportedly used by "working girls." Today, the building serves as a wine bar. *Author's collection.*

to lock her up several times for violating the red-light injunction against her house—a comparatively rare procedure in actual abatement practice. But we were unable to deport Mary Selowski. By a strange freak in the law she was able to acquire citizenship through marriage. Once having gained citizenship by marrying a United States citizen, she was beyond the law of deportation. She evidently knew it and speeded up her traffic in crime accordingly.

Later, the Stone Bridge was run by a madam known as Penny Parker. Penny managed to keep the Napa Valley's male clientele serviced well into the 1950s. Her undoing was a new neighbor who, unfortunately for Penny, started getting misdirected gentleman callers at her front door. Sheriff John Claussen finally came calling to the Stone Bridge and closed Penny down for good.

The Palmer House, located in Calistoga at 1300 Cedar Street, was built by Judge Augustus Palmer. It later reportedly housed a brothel and is the site of reported sightings of a ghostly apparition of the brothel's madam. *Author's collection*.

It seems each town of any size within the valley possessed a house of ill fame. Yountville is positioned halfway between the cities of Napa and St. Helena along the north–south thoroughfare today known as Highway 29. Locals remember at least two brothels operating in the town: one catered to the veterans who lived at the nearby Veterans' Home of California, and the other pandered to the Hispanic field workers who toiled in the local vineyards and orchards.

Another up-valley house of ill fame was run at 1300 Cedar Street in Calistoga. The Victorian house was built in 1871 by a local justice of the peace and most recently was home to an upscale bed-and-breakfast. Some say that the ghost of the house's madam now haunts it, trapped as a result of her untimely death by falling down a flight of stairs.

The romanticized image of Victorian brothels and madams, embodied in May Howard and Penny Parker, has now been replaced by freelance prostitutes, many of whom have adopted the Internet as a means of advertising their unique services. These mobile practitioners travel between the Napa Valley and neighboring counties, lacking a fixed address, making it more difficult for law enforcement to come calling to shut them down.

CHAPTER 22
THE GREAT ESCAPES

For as long as there have been people willing to commit crimes, there have been the resulting dilemmas of how to punish them and, indeed, how to ensure they don't commit further crimes while awaiting trial.

As the Napa Valley began to become populated with "Californios" (Mexican citizens) and later by American settlers, crime naturally followed them. Before the founding of the state, justice was meted out by an alcalde based in the nearby town of Sonoma, just over the mountains in present-day Sonoma County. The first place Napa criminals were housed wasn't even in the Napa Valley but in the Sonoma jail. It is believed that General Mariano Vallejo, the original Mexican land grantee, built the first jail, an adobe structure located northwest of the Sonoma Mission. In an ironic twist, the site of the first jail is now the parking lot of the present-day Sonoma Police Department.

The first Napa County Courthouse was built in 1851. It was a rather small, two-story wooden structure that housed a single courtroom on the first floor and the court clerk's office on the second. The second floor also doubled as a makeshift jail for petty criminals, who were shackled to the floor. Anyone committing a serious crime was carted off to what became known as the "old adobe jail" in Sonoma.

The first Napa jail was erected in 1859, built by the firm of Benjamin and Sanford for the sum of $7,000 (about $1 million in today's money). At first, Napa's jail seemed quite formidable: an outer walled courtyard constructed with ten-inch-thick stones, with an inner free-standing cell block

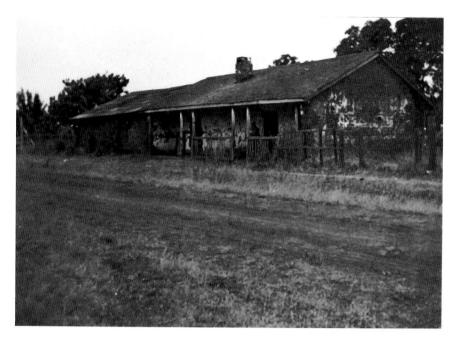

The old adobe structure known as General Mariano Vallejo's jail, located at the edge of his rancheria in the town of Sonoma. Napa County sent many of its prisoners here until a local jail was built. *Courtesy of Sonoma Valley Historical Society.*

constructed of twelve-inch-thick stones and iron gated cells within the block. Unfortunately, in 1865, the citizens of Napa would learn that it seemed better than it really was. The sheriff had spent the day washing out the jail cells and, fearing that the damp conditions would make the prisoners sick, allowed them to sleep overnight with their cells unlocked. He was confident in the security of the cellblock's walls. The next morning, the sheriff discovered that all four prisoners had used the cover of darkness to escape. It seems that the contractor who built the cellblock was supposed to connect each stone with two iron rods; however, in a cost-cutting maneuver, the contractor omitted some of the rods. It was thus fairly easy for the determined prisoners to loosen the mortar and take out one of the wall's stones. Once out of the cellblock, the prisoners found the weakest part of the outer wall, the privy (bathroom). They dug a hole through the brick that made up the wall and were free.

Without a doubt, the most colorful person to ever cross the threshold of the Napa County jail wasn't an inmate but a jailer named William Kennedy. Known to everyone around town by his nickname, "Wall," Kennedy called

himself "Old Desperate." He served as the jailer from 1879 until 1900. Kennedy led an adventurous life before landing in the Napa Valley. A native of Indiana, he left home at the ripe old age of twelve to work as a teamster for the U.S. Cavalry as it pushed west during the Mexican-American War. Kennedy came to California during the gold rush of 1849 and spent six years trying to strike it rich in the foothills. It was during this time that Kennedy first made a name for himself as a lawman, allegedly running some desperados out of the mining town of Placerville. He returned to the Midwest in 1859, just in time to join the Union army and fight during the Civil War. He was wounded in two separate battles, sustaining wounds in his leg, shoulder and head. In 1864, Kennedy and his family returned to California, settling in the Napa Valley. He worked as a foreman for the Santa Rosa Railroad for fifteen years before taking on the job as Napa County jailer at the age of forty-six.

Kennedy was known for his social nature and as a master of the tall tale. He entertained inmates and citizens alike with vivid yarns. Probably the best-known tale involved Kennedy "herding" swarms of bees to California

Napa County jailer William "Wall" Kennedy was photographed by friends in this staged photograph in 1899. He served as jailer from 1879 until his death in 1900. *Courtesy of the Napa County Historical Society.*

from Missouri, camping near wildflower fields to feed them. He trained them to recognize his voice and a shrill whistle and used them as defense against Indian attacks. A local journalist and aspiring actor named Frank Bacon was inspired by Kennedy and his tales to write a play called *Lightnin'*, which featured an eccentric older protagonist named Lightnin' Bill Jones. The play had successful runs in San Francisco and other West Coast cities before also having successful runs in Washington, D.C., and New York City. Bacon also wrote a book based on his play, which would later be made into a movie starring noted actor and social commentator Will Rogers.

Kennedy served as jailer until just before his death in 1900. He was eulogized in the *Napa Register*: "Though he walked in a humble sphere, he sought and attained the noblest object of his life, that of affording happiness to others."

The use of chain gangs was common in early penal institutions, including the Napa County jail. The free labor provided by prisoners stood in for the

The chain gang busy working in the city of Napa at the intersection of Coombs and Division Streets, under the direction of Jailer William Kennedy (pictured at far right), circa 1895. *Courtesy of the Napa County Historical Society.*

lack of public works departments. Chain gangs were frequently enlisted to maintain and, indeed, improve the conditions of city streets. Perhaps the *Napa Daily Register* put it best in 1880 when it said, "The city authorities seem to think that if a man is a success as a law breaker, he ought to excel as a stone breaker—and he usually does." Jailer Kennedy was known to roll up his sleeves, working side by side with the inmates to grade streets, flush sewers and build sidewalks.

Although most prisoners saw their time on the chain gang as an opportunity to get out of their cramped cells, even if it meant backbreaking labor, some saw it as a different type of opportunity: a chance to make a break for freedom. No doubt these feelings were aided by the fact that chain gang members in Napa were rarely actually chained and the guards typically were armed with nothing more than billy clubs.

Shortly after Kennedy's death, in 1901, a headline in the *Napa Daily Journal* announced: "Prisoners Break for Liberty." Jailer Behrens was supervising three inmates downtown on Division Street when one, Earl Hurstay, took flight. When Behrens chased after Hurstay, the other two inmates decided they should take advantage of the situation to run too. The three were described by the *Journal* as "hard cases," serving time for stealing a bicycle and vagrancy. Within a few days, all three were back in custody working on the chain gang, this time secured with leg shackles.

Several years later, in March 1904, jailer Behrens took a group of three inmates to First Street, near Groh's Stables, to work on the road. At about 10:00 a.m., one of the prisoners, William Williams, made a break for it. He was serving a short sentence for throwing a stone through a saloon window. A posse was formed, including Sheriff Dunlap, Undersheriff Daly and Constables Secord and Allen. By 3:00 p.m., the search of the city had turned up nothing, so Sheriff Dunlap and Constable Allen followed a hunch and started east toward the town of Sonoma. By 5:30 p.m., the lawmen had their man. They found Williams walking in downtown Sonoma. Williams tried to deny his identity, but he was safely back behind bars in Napa before the end of the day.

Even into the twentieth century, periodic jailbreaks plagued the Napa County lockup. In 1951, two inmates made a break for it with the help of a hacksaw. They were able to cut the lock on a ceiling access hatch in the common area of the jail, accessing a second-floor room that was used for fingerprinting. Their plan was to cut their way out through the roof; however,

The common area of the Napa County jail, circa 1957. The jail would later be deemed a fire hazard by the state fire marshal due to outdated construction and overcrowding. *Courtesy of the Robert E. McKenzie Collection of the Napa Police Historical Society.*

the alarm was raised before they could escape. The jailbirds quickly retreated to their cells, but the hacksaw was found secreted in a pillowcase.

In 1960, three inmates attempted nearly the same escape, this time with deadly results. The group was led by Paul T. Sherman, who was awaiting sentencing for armed robbery. Two other inmates, William O. Hallmark and James Cooper, helped Sherman in the two-hour task of sawing through the bars that blocked a ceiling ventilation shaft. The trio cut a hole in the shingle roof of the jail before one of the jailers discovered the breakout. Deputy Sheriff Joe Meyer confronted the trio, who were armed with what appeared to be pistols, on the roof. Meyer shot and killed Sherman, forcing the other two to retreat back into the jail. After everyone was safely locked in their cells, the deputies discovered that the pistols were actually toy cap guns.

In response to the escape, the *Napa Register* did an exposé on the substandard conditions in the then-eighty-six-year-old jail. Despite state laws against it,

Napa County sheriff's deputy Mike Chouinard inspects the damage to the Napa County jail's roof after a breakout in 1960. *Courtesy of the Robert E. McKenzie Collection of the Napa Police Historical Society.*

felony and misdemeanor prisoners had to be mixed together because there was no way to separate their common area. The jailers couldn't even lock the prisoners in their individual cells because they lacked toilets. Overcrowding forced the placement of some prisoners on cots in the hallways. Prisoners considered too dangerous had to be shipped off to neighboring Solano County and housed there. Yet despite these glaring issues, little was done to change the status quo for four more years.

Finally, in 1964, the state fire marshal inspected the facility and deemed it a fire hazard. He issued an ultimatum to the sheriff: transfer the prisoners someplace else or leave at least one exit door open as a fire escape route.

Sheriff John Claussen chose to unlock the door, leaving an armed deputy guarding it 24/7.

In 1966, yet another daring escape was hatched. Under cover of darkness, two inmates—Gilbert Vernon Conley and David Faulkenberry—using smuggled hacksaw blades were able to saw their way through the bars on the window of their cell on the jail's second floor. They then jumped down about twelve feet, using shrubbery next to the building to break their fall. Conley was awaiting trial for strangling a woman, and Faulkenberry had recently been convicted of manslaughter in connection with a drunk-driving accident. The authorities were alerted when a citizen called the Napa police after witnessing the men make their jump from the window and hop into a car; the police called the jailer, who was none the wiser. A police officer spotted the car, and a wild chase ensued through the streets of downtown Napa. After a few minutes, the car was able to get away. The duo enjoyed their freedom for about two hours until another officer spotted the car on Silverado Trail on the east side of town. After another short chase, the car was stopped, and Conley and his girlfriend were arrested. Once Conley was in custody, the police grilled the girlfriend, who admitted that Faulkenberry was hiding at his girlfriend's apartment in downtown Napa.

This final escape hammered home the need for a new county jail. The process had been started in 1964, when a series of bond measures was voted on to provide funding to build a hall of justice and jail. Although the voters turned down the first bond, it was later approved. In 1976, the new facility opened across the street from the outdated one. It was further expanded in 1984.

Today, the Napa County jail is again experiencing growing pains, exacerbated by the state's decision to transfer some prisoners back to the counties. Discussions are ongoing about either expanding the current facility or building a new one in an outlying area of the county.

BIBLIOGRAPHY

BOOKS

Bancroft, Hubert Howe. *Popular Tribunals: Volume 1*. San Francisco: History Company Publishers, 1887.

Bartlett, John Russell. *Bartlett's Personal Narrative of Explorations and Incidents in Texas, New Mexico, California, Sonora, and Chihuahua*. New York: D. Appleton & Company, 1855.

Coodley, Lauren, and Paula Amen Schmidt. *Napa: The Transformation of an American Town*. Charleston, SC: Arcadia Publishing, 2007.

Haas, Robert Bartlett. *Muybridge: Man in Motion*. Berkeley: University of California Press, 1976.

Heize, Robert F. *Collected Documents of the Causes and Events in the Bloody Island Massacre of 1850*. Berkeley: University of California Press, 1973.

Jackson, Steve. *No Stone Unturned: The True Story of the World's Premier Forensic Investigators*. New York: Kensington Publishing, 2002.

Margolin, Malcolm, ed. *The Way We Lived: California Indian Stories, Songs & Reminiscences*. Berkeley, CA: Heyday Books, 1993.

McCormick, Rodney. "My Clothesline Rope." Unpublished manuscript, 1939.

Menefee, C.A. *Historical and Descriptive Sketch Book of Napa, Sonoma, Lake and Mendocino Counties*. Napa, CA: Reporter Publishing House, 1873.

Munro-Fraser, J.P. *History of Sonoma County: Including Its Geology, Topography, Mountains, Valleys and Streams; With a Full and Particular Record of the Spanish*

Grants; Its Early History and Settlement. San Francisco: Alley, Bowen & Co., 1880.

Secrest, William B. *Perilous Trails, Dangerous Men: Early California Stagecoach Robbers and Their Desperate Careers 1856–1900.* Clovis, CA: Word Dancer Press, 2002.

Shulman, Todd L. *Images of America: Napa County Police.* Charleston, SC: Arcadia Publishing, 2007.

Solnit, Rebecca. *River of Shadows: Eadweard Muybridge and the Technological Wild West.* New York: Penguin Books, 2003.

Warner, Barbara. *The Men of the California Bear Flag Revolt and Their Heritage.* Sonoma, CA: Arthur H. Clark Publishing, 1996.

Weber, Lin. *Old Napa Valley: The History to 1900.* St. Helena, CA: Wine Ventures Publishing, 1998.

———. *Roots of the Present: Napa Valley 1900 to 1950.* St. Helena, CA: Wine Ventures Publishing, 2001.

Wilcox, Mrs. B.C. *The Death Penalty: The Men Who Have Suffered It at San Quentin Prison.* N.p., 1903.

NEWSPAPERS

California Farmer & Journal of Useful Sciences. "Death of J.W. Osborn: A Pioneer Gone." April 24, 1863.

———. "The Family of J.W. Osborn." May 1, 1863.

Courtney, Kevin. "Officials, Chinatown's Descendants Pay Homage at the New First Street Bridge. *Napa Valley Register,* January 14, 2006.

Daily Alta California. "The Butler Murder." January 10, 1882.

———. "The Calistoga Shooting Affair." April 21, 1868.

———. "The Governor's Reprieve." April 18, 1851.

———. "The Indian Outrages in Napa Valley." March 19, 1850.

———. "The Indians—Their Enemies." March 11, 1850.

———. "The Kelseys and the Indians." September 13, 1850.

———. "Law Courts." May 4, 1851.

———. "The Murder of J.W. Osborn." April 21, 1863.

———. "Oak Knoll Views." August 22, 1863.

———. "The Recent Outrages Upon the Indians." March 16, 1850.

———. "Shooting Affray at Calistoga: Samuel Brannan Shot and Seriously Injured." April 18, 1868.

———. "The Trial of Britton for the Murder of Osborn." June 6, 1863.

Ellensburg Daily Record. "Slayer Dies in Nevada Chamber." July 15, 1954.

Johnson, Charles. "Napa's Red Light District Was Biggest in North Bay." *Napa Register*, 1976.

Los Angeles Herald. "Killed His Fiancee for Refusing a Request to Marry Promptly." March 18, 1898.

———. "The Murder of Mr. J.C. Weinberger." March 26, 1882.

———. "A Startling Tragedy." October 22, 1874.

Milwaukee Journal. "Two Escaped Convicts Are Soon Retaken." April 24, 1943.

Napa County Reporter. "$500 Reward." June 1, 1888.

———. "The Grand Jury." May 25, 1888.

———. "Murder and Suicide." March 24, 1882.

———. "Murder at St. Helena." April 27, 1888.

———. "Murdered for Love: The Spanishtown Tragedy." May 15, 1875.

Napa Daily Journal. "The Allen Case." September 6, 1898.

———. "A Break Prevented." July 7, 1895.

———. "Crazed by Love: The Chiles Valley Tragedy the Results of Unrequited Love." March 18, 1898.

———. "English Arraigned." July 9, 1895.

———. "English Gets Life." July 10, 1895.

———. "English Held to Answer." July 7, 1895.

———. "Expiation: Murderer Roe Pays the Penalty for the Killing of Mrs. J.Q. Greenwood." January 15, 1897.

———. "Grant Asks for Clean-Up: Vice Crusader Says Conditions in Napa County Are Bad." May 8, 1918.

———. "The Jury's Verdict: Story of Terrible Tragedy Related Before Coroner's Jury Tuesday Afternoon." June 13, 1906.

———. "Murder and a Suicide: Carrie Clark Killed by Paramour, Roy Spurr." June 12, 1906.

———. "Notices Served: All Disreputable Women Have Been Ordered to Leave Town." March 21, 1908.

———. "Prisoners Break for Liberty." January 31, 1901.

———. "A Reminder of Roe: His Statement that He Had a Pistol in Jail Verified." March 15, 1898.

———. "Roe's Ghost Walks." October 9, 1898.

———. "Twenty-Five Years." May 30, 1895.

———. "Was Allen Murdered?" September 4, 1898.

Napa Daily Register. "Another Homicide: Woman Killed in Spanishtown." May 10, 1875.

———. "Captured! The Mirabel Stage Robbers Brought to Napa." May 10, 1895.

———. "Held for Trial." May 24, 1895.

———. "Held Up! The Calistoga and Lower Lake Stage Stopped Near Mirabel Mine." May 10, 1895.

———. "How They Stood." February 8, 1875.

———. "The Muybridge Trial." February 3, 1875.

———. "The Muybridge Trial: Thursday." February 5, 1875.

———. "The Muybridge Trial: Wednesday." February 4, 1875.

———. "Not Guilty: The End of Muybridge Trial." February 6, 1875.

———. "The Pearce Murder Case." October 7, 1875.

———. "The Pearce Murder Case." October 8, 1875.

———. "The Public Gratified: What Is Said of the Successful Trip of the Sheriff's Posse." May 17, 1895.

———. "Sentence of Henry Pearce: 20 Years in the State Prison." October 14, 1875.

———. "The Spanishtown Murder Examination of Pierce." May 11, 1875.

———. "The Stage Robbers." May 17, 1895.

———. "The Verdict: Murder in the Second Degree." October 9, 1875.

Napa Daily Reporter. "The Butler Murder Case." April 21, 1882.

———. "A Chinese Jail Bird Suicided." March 10, 1882.

———. "A Revolting Murder: Young Butler the Victim of Two Murderous Celestials." January 13, 1882.

———. "Supposed Murder." December 23, 1881.

Napa Journal. "Hallmark, Cooper Due in Court Wednesday on Escape Charges." February 4, 1960.

———. "Jail Setup Violates State Law." February 4, 1960.

Napa Register. "DeLaCasa, Fugitive Gunman, Shot to Death in Los Angeles." January 25, 1949.

———. "5-Year-Old Napa Girl Missing." March 23, 1963.

———. "Gunman Hunted, One Caught After 2 Napa Officers Shot." October 18, 1948.

———. "Gunman Identified as Ex-Convict." October 23, 1948.

———. "Gunman Taken to San Quentin." October 19, 1948.

———. "Jail Continues to Be 'Persistent' Problem." January 21, 1964.

———. "Jail Door Is Opened; Other Actions Taken: Move to Protect Prisoners." February 6, 1964.

———. "State Report Finds County Jail Substandard Building." January 6, 1960.

Napa Valley Register. "Bawdy Babes and Brothels in Napa's Infamous Red Light District." March 21, 2010.

———. "Former Investigators Elated by Break in 1974 Andrews Case." January 25, 2010.

———. "History Revealed: Four Years Makes a Difference." September 16, 2010.

———. "Melanson Gets Life in Prison for 1974 Murder." October 27, 2011.

———. "Sam Brannan: Pioneer, Dreamer and Scoundrel." February 18, 2011.

———. "Who Killed Anita Andrews? Thirty Years Later, the Main Street Murder Still Stumps Authorities." July 11, 2004.

Napa Weekly Register. "The Calistoga Shooting Affray." April 18, 1868.

Oakland Post Enquirer. "4 Shot in Wild Napa Gun Fight." October 18, 1948.

Oakland Tribune. "Posse Trails Desperado." October 18, 1948.

Reading Eagle. "Two Missing Prisoners Sought on Jail Grounds." April 23, 1943.

Sacramento Bee. "FBI Joins Search as Hunt for Napa Gunman Spreads." October 19, 1948.

Sacramento Daily Record-Union. "Important News: A Prisoner in Denver Confesses to the Greenwood Murder." February 2, 1892.

———. "Murder of Mrs. Greenwood." November 19, 1896.

———. "Schmidt Sentenced." June 3, 1892.

Sacramento Daily Union. "Attempted Suicide." April 17, 1882.

———. "Britton Convicted of Murder in the First Degree." June 11, 1863.

———. "The Death of J.W. Osborn." April 22, 1863.

———. "The Late Affray at Calistoga." April 29, 1868.

———. "Murder in the Second Degree." April 21, 1882.

———. "Possibly a Murder." December 21, 1881.

———. "Suicide in a Prison Cell." March 7, 1882.

———. "Trial of Charles Britton." June 6, 1863.

———. "Two Mexicans Killed." April 21, 1868.

Sacramento Transcript. "Exciting News from Napa! The Murder McCauley Hung in Secret." May 19, 1851.

———. "Full Particulars." May 19, 1851.

———. "The Late Tragedy of Napa City." March 4, 1851.

———. "Relating to the Murder of Mr. Sellers." March 28, 1851.

———. "Sentenced to Be Hung!" March 17, 1851.

———. "Tragic Affair in Napa City!" March 3, 1851.

San Francisco Call. "Attorney Accused of Inebriety." March 16, 1898.

———. "Blames the Woman for His Crime." March 22, 1898.

———. "Brutal Murder Near Calistoga." May 10, 1902.

———. "Captured Near Napa: Middletown Stage Robbers Taken into Custody." May 10, 1895.

———. "Clark Accused of Fratricide by Coroner's Jury." January 31, 1898.

———. "Clark an Enigma to His Counsel." February 6, 1898.

———. "Clark Held to Answer." January 29, 1898.

———. "Clark Now Regrets His Confession." January 24, 1898.

———. "Clark Pays the Death Penalty." October 22, 1898.

———. "Clark to Hang for His Crime." March 23, 1898.

———. "Convicted by His Own Poor Wit." March 17, 1898.

———. "Death by Poison Self Administered Ends a Pathetic Family Tragedy." July 21, 1901.

———. "Demands that He Be Tried for Murder." September 6, 1898.

———. "Double Tragedy in the Napa Wilds: Murder and Suicide on a Lonely Road." March 18, 1898.

———. "Establishing Clark's Guilt." March 18, 1898.

———. "Excludes the Clark Confession." March 19, 1898.

———. "Fratricide Clark Faces Citizens of St. Helena." January 28, 1898.

———. "The Fratricide Fears the Trip to St. Helena." January 27, 1898.

———. "George Clark to Plead Insanity." February 11, 1898.

———. "The Greenwood Murder: A Large Quantity of Chloroform and Arsenic Found in the Woman's Stomach." February 25, 1891.

———. "Her Inquiry Came Too Late." January 20, 1897.

———. "Moore's Trial for Murder at Napa." November 14, 1896.

———. "Moral Imbeciles Are This Man and Woman." January 25, 1898.

———. "Mrs. Clark Visits the Murderer." January 26, 1898.

———. "Murder and Suicide End Quarrel in City of Napa." June 13, 1906.

———. "Murder Charged by a Dying Man: Accusation Against an Aged Negro." September 4, 1898.

———. "Napa Escape Foiled: An Attempted Jailbreak Frustrated by a Sheriff." July 7, 1895.

———. "Napa Men Know Moore." September 27, 1896.

———. "Napa Witnesses Accuse Moore." November 12, 1896.

———. "Practically No Defense for Clark." March 20, 1898.

———. "Proof that Roe Told the Truth." November 18, 1896.

———. "Roe Is Hanged for His Crimes." January 16, 1897.

———. "Schmidt in Court." January 22, 1892.

———. "Searching Napa County Hills for a Murderer." May 11, 1902.

———. "Shoots Woman, Then Kills Himself." June 12, 1906.

———. "Thank You, Said Murderer Roe." November 25, 1896.

———. "Was Clark in Love with His Brother's Wife?" January 21, 1898.

———. "Weaving a Web Around Moore." November 13, 1896.

———. "William A. Clark Is Slain by His Brother George." January 11, 1898.

San Francisco Examiner. "4 Shot as Napa Police Battle Auto Bandits." October 18, 1948.

———. "Napa Outlaw Abandons Car at Vallejo." October 19, 1948.

San Francisco News. "Napa Gunman Hunted." October 18, 1949.

St. Helena Star. "Weinberger: The Tragedy of Lodi Station." March 24, 1882.

Telegraph-Herald. "Two Escapees at Folsom Prison." April 23, 1943.

Vallejo News-Chronicle. "2 Escapees Recaptured by Napa Police Officers." January 19, 1966.

Vallejo Times-Herald. "Fire Marshals Give Ultimatum on Napa Jail." March 27, 1963.

Magazines and Periodicals

Bishop, Malden Grange. "California's 1949 Trial by Gunfire." *Headquarters Detective*, July 1949.

Chegwyn, Michael. "Jailhouse Wall: The Frontier Wit of William Wallace Kennedy". *Gleanings* 5, no. 5 (November 1995).

———. "One Killing Too Many." *True West*, November 1991.

Parmelee, Robert D. "Help Restore the Sonoma Adobe." *California Historian*, June 1991.

ONLINE RESOURCES

California Supreme Court Historical Society. "History of the California Supreme Court." Accessed January 10, 2012. cschs.org/02_history/02_a. html.

Find a Grave. "Henry Fowler." Accessed January 10, 2012. findagrave.com/cgi-bin/fg.cgi?page=gr&Grid=29552912.

Grant, Edwin E. "Scum from the Melting-Pot." *American Journal of Sociology* 30 (1925): 641–51. Accessed February 20, 2012. www.brocku.ca/MeadProject/Thomas/Supplementary/Grant_1925.html.

Hansen, Mariam. "St. Helena's Chinese Heritage." St. Helena Historical Society. June 2011. Accessed March 23, 2012. www.shstory.org/wp-content/uploads/2011/12/Chinese-Heritage-of-St-Helena-by-Mariam-Hansen.pdf.

National Park Service. "Bloody Island: Lake County." Accessed January 10, 2012. www.cr.nps.gov/history/online_books/5view/5view1h8.htm.

Pogue, Lindsey. "Bawdy Babes and Brothels in Napa's Infamous Red-Light District." *Napa Valley Register*. March 21, 2010. Accessed April 12, 2011. napavalleyregister.com/lifestyles/real-napa/article_1bc4c97e-347c-11df-ab28-0011cc.

Rohde, Jerry. "The Sonoma Gang." *North Coast Journal*. September 11, 2008. Accessed October 10, 2011. www.northcoastjournal.com/news/2008/09/11/sonoma-gang.

Wikipedia. "Bennett C. Riley." Accessed January 10, 2012. en.wikipedia.org/wiki/Bennett_C._Riley.

———. "Bloody Island Massacre." Accessed January 10, 2012. en.wikipedia.org/w/index.php?oldid=462978910.

———. "Pacific Squadron." Accessed January 10, 2012. en.wikipedia.org/w/index.php?oldid=469190117.

———. "Samuel Brannan." Accessed December 12, 2011. en.wikipedia.org/wiki/Samuel_Brannan.

———. "USS Savannah (1842)." Accessed January 10, 2012. en.wikipedia.org/wiki/USS_Savannah_%281842%29.

Yerger, Rebecca. "Sam Brannan: Pioneer, Dreamer, Scoundrel." *Napa Valley Register*. February 18, 2011. Accessed January 20, 2012. napavalleyregister.com/inv/lifestyles/sam-brannan-pioneer-dreamer-and-scoundrel/article_600ee514-3ae9-11e0-8969-001cc4c002e0.html.

ABOUT THE AUTHOR

Todd L. Shulman has worked in law enforcement his entire adult life; he began as a military police person in the U.S. Army, serving during the First Gulf War. Later, Shulman became a police officer in California; he currently works at the Napa Police Department. He has held positions within the police department as a detective, training officer, crime scene specialist, computer forensic examiner, corporal and cold-case investigator. Shulman formed the nonprofit Napa Police Historical Society in 2006 and continues today as its president. Shulman is a member of the Napa County Historical Society. He is married with two teenage sons. He enjoys attending his kids' sporting events and is an avid postcard collector and scale model collector and builder.